A Short Book About Art
Dana Arnold

In memory of Arnie

Dana Arnold

A Short Book About Art

Tate Publishing

First published 2015 by order of the Tate Trustees
by Tate Publishing, a division of Tate Enterprises Ltd,
Millbank, London SW1P 4RG
www.tate.org.uk/publishing

A catalogue record for this book is available from the British Library

ISBN 978 1 85437 907 8

Designed by Inventory Studio, London
Colour reproduction by DL Imaging, London
Printed by Grafos in Barcelona, Spain

Contents

Looking

Art is not
what you see,
but what
you make
others see

EDGAR DEGAS (1834–1917)

Looking

Art is not what you see, but what you make others see.
Edgar Degas (1834–1917)

What do we see when we look at art? The makers and viewers of art may see the same object differently and these interpretations become more diverse across time periods and cultures. We like to think of art as having meaning, significance and appeal to humankind through the ages. We attribute visual material with having a kind of autonomous existence that makes us see the world around us in new ways. Perhaps most importantly, we enjoy looking at art for its own sake and can appreciate it independent of any knowledge of its context. A Sunday afternoon wander through an art gallery can be a very personal, aesthetically pleasing experience. It can make us feel good.

My aim in this short book about art is to explore the ways in which we look at art and to think about what others might see when viewing the same object. I suggest some common threads that bind together art from broad geographies to show that art from all periods operates similarly. These themes enable us to consider art and its various meanings.

My themes suggest how we can look simultaneously at works of art from across the world. In this way we might move away from the kinds of narratives where art from cultures outside the West is judged by Western standards. It is tempting, for instance, to see African or Shaman art as 'primitive', that is, naively conceived. When we discuss the late nineteenth- and early twentieth-century movement in Western art known as Primitivism we acknowledge that these artists draw on

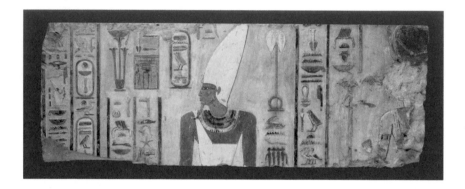

[01] **RELIEF OF NEBHEPETRE MENTUHOTEP II** (DETAIL)
MIDDLE KINGDOM, DYNASTY 11, C.2051–2000 BCE

their so-called primitive sources. However, we see the art as having added 'value' because the works are produced self-consciously by the West to appeal to Western intellectual sensibilities. They are represented as improving on their 'primitive' inspiration. Progress is essential in this narrative.

From Caveman to Picasso
—

The thematic structure of the book allows a discussion of these issues, which can stand outside the usual surveys of art focusing on the great artist and the notion of progress. These broad chronological sweeps are sometimes referred to by art historians as surveys spanning 'from caveman to Picasso', a point to which I shall return. I use this well-known phrase deliberately because it typifies the idea of twentieth-century Western art as being the apogee of progress and sophistication. But art has carried on since the time of Pablo Picasso (1881–1973) and this is the problem with looking for continuous progress in art or indeed any kind of history. The end point – the moment at which history is written – is not fixed; instead, as time moves on, it is subsumed into the narrative.

The general survey is the mainstay of both museum displays and histories of art. Extra chapters are often added to new editions of surveys of art to bring the volume back up to date. This approach impacts on the way in which art is displayed and influences how we think about it. When we enter an art gallery we are not surprised to find the collection presented to us chronologically. Let us take a virtual whistle-stop tour of a 'Western' art museum. My examples are provocative, but my intention is to make some very basic points about how consider art, how it is displayed and what we are made to see when we look at it.

In our virtual museum we might walk through a few rooms of prehistoric art – sometimes referred to as primitive. It is not unusual to find art from across the world in these kinds of displays. From here on we might find world art categorised and displayed by specific geographies rather than time periods – Oceania, Asia and the near East are familiar terms in this regard. The 'main' story might move on to the stylised human and animal forms of Mesopotamian and Egyptian art. We see this for instance in the *Relief of Nebhepetre Mentuhotep II* c.2051–2000 BCE (FIG.01) in the Metropolitan Museum of Art, New York.

After this the naturalism of ancient Greek is presented as progress towards the realistic representation of the world as we see it. The perfect proportions found in the sculpture of the Greek athlete or mythological god from the classical period are echoed in their Roman descendants. The *Apollo Belvedere* c.120 CE (FIG.02) is typical of this kind of sculpture. It is a Roman marble copy measuring 2.24 metres in height of a Greek bronze original (350–325 BCE) and was discovered in Italy during the Renaissance. It became known as one of the most perfect works from the ancient world and has had a resounding influence on Western art.

The narrative continues to Byzantine and then to medieval art, which can seem like a step backwards in our march towards the accurate representation of the world. A lack of interest in naturalism means that we see precious stones and metals, especially gold, as expressions of wealth and devotion. The *Madonna Nicopeia* in St Mark's Basilica in Venice exemplifies this kind of image (FIG.03). This Byzantine icon, which dates from the twelfth century, survived intact until the late twentieth century when many of the jewels were stolen from both the frame and the image itself, raising interesting questions about the monetary and artistic value of works of art.

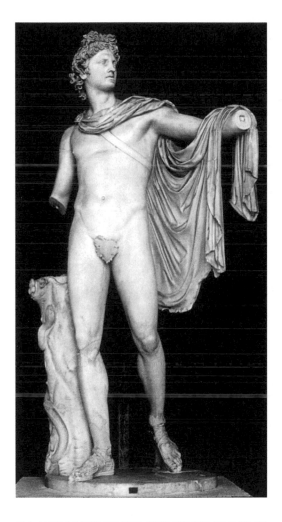

[02] **APOLLO BELVEDERE** ANCIENT ROMAN, C.120 CE

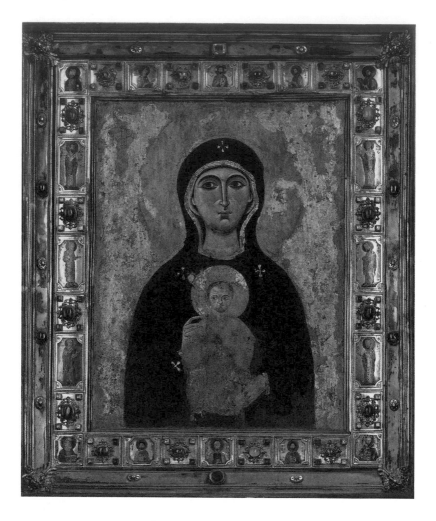

[03] **MADONNA NICOPEIA** C.12TH CENTURY

Nature is rediscovered in the art of the Renaissance and from there we see various manifestations of the human form and representations of light and nature. All of which is, of course, artifice. This Western focus continues from the sixteenth to the eighteenth century when portrait, genre and history painting endure as secular counterpoints to the religious art of the Catholic Church. In all of these artworks the representation of the human figure remains a key element. By the nineteenth century in Europe and America we see a dissembling of the picture surface as brushstrokes and paint become more evident – or less concealed. *Girl on a Divan (Jeune Femme au Divan)* c.1885 (FIG.04) by Berthe Morisot (1841–95) shows us the more casual way in which the artist can engage the viewer. The anonymous subject stares out at us, her facial expression all the more enigmatic as a result of Morisot's painting technique. Her dabs of paint are suggestive and we need to use our imagination and 'join the dots' to complete the picture. By the end of the nineteenth century we begin to leave figurative art behind as we see works presenting us with conceptual ideas and abstract notions of our own world. Our fictional tour, in this instance with an emphasis on the human form, is in fact just one way of seeing art using the tool of chronology. My aim here is to present a different view of how art relates to time. I would also like to think about how we encounter and experience art. By this I mean how physical objects are presented to us and what we bring to them as viewers.

There are various ways in which art from across time can be discussed, written about and presented to us in galleries and museums. These influence how we see art and indeed what it can be seen to do. We can enjoy art through art appreciation, art criticism and art history, all of which are different approaches to understanding, experiencing and seeing art. Art history brings an historical dimension to aspects of art appreciation, what we might

term the aesthetic enjoyment of art, and art criticism. But this historical narrative imposes a chronology and with it comes the idea of progress through time. Our history books are full of events in the past that are presented as part of either the continual movement towards improvement, or as stories about great men or epochs of time that stand out from each other – for instance the Italian Renaissance or the Enlightenment. Therefore, our judgements about art and our viewing of it are influenced by the way its history is told. As the coming together of the two separate strands of art and the forces of history, we see how history re-orders visual experience. This can lead us to accept that writing about the history of art from the point of view of artists – usually 'great men' – or of artistic styles of the great epochs of the history of art, for example Renaissance, Baroque or post-impressionism, is the only way to do it. We can also become a little preoccupied with tracing stylistic change, or developments, using our knowledge of what came after a particular artwork or art movement. This is encouraged by the ways in which art is displayed in many museums and galleries. As our virtual museum tour has shown, it is possible to trace a history of artistic form using, for instance, representations of the human body and including judgements about naturalism, realism and abstraction. We could also do it using other kinds of representations, and here is my starting point for this book: bulls.

Caveman and Picasso
—

I would like to begin with two stories of art from France in the 1940s, which in fact set up much of what I discuss throughout the book. The images on the walls of the caves at Lascaux are some of the earliest forms of art known. The enigmatic representations of animals, humans and abstract forms, made over 17,000 years ago,

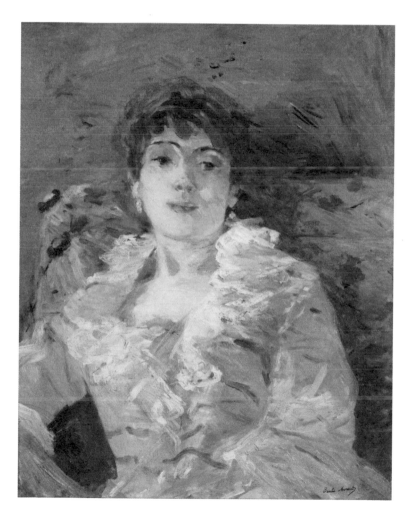

[04] BERTHE MORISOT, **GIRL ON A DIVAN** C.1885

remain objects of fascination. We do not know what they meant to those who made them or why there are so many of them – almost 2,000 in total. The images are painted directly onto the walls with mineral pigments, although some designs have also been incised into the stone. The paintings contain no images of the surrounding landscape or the vegetation of the time. This absence of any context can seem surprising to a present-day viewer. Similarly, the representations of the various animals are drawn to different scales that make the array of images even more intriguing.

In order to understand the images and the spaces in which they are displayed we try to map them onto our own experiences and knowledge so we can make sense of a disordered world. We see animals – a hunting scene perhaps? Are these then votive offerings by those (men) who were about to go in search of their next meal? Or were the first artists in fact women, who decorated the caves while waiting for the men to bring home the bison? The caves comprise a series of spaces, which we now refer to as if they were rooms in a European building. The Hall of the Bulls, the Passageway, the Shaft, the Nave, the Apse and the Chamber of Felines suggest domestic and religious architecture, but these names are projections from our world onto an unfamiliar past.

The cave complex was opened to the public in 1948. Only seven years later the paintings had been damaged by the carbon dioxide produced by the hundreds of visitors that passed through each day. So in 1963 Lascaux was closed and the paintings restored. Unfortunately, since then the caves have been blighted by a fungus that continues to compromise the paintings. Now tourists queue up a little way from the original caves to visit Lascaux II – a replica, opened in 1983, of part of the caves that includes the Great Hall of the Bulls (FIG.05). There are more reproductions of the Lascaux paintings in

the nearby Centre of Prehistoric Art in the town of Le Thot, but my interest remains with the facsimile of the caves themselves. It raises questions about the originality of artworks, or rather what we are prepared to accept as authentic. The Lascaux II experience prompts me to query how the spaces in which we encounter these copies affect the ways in which we view them. If the copies of the images were framed and hung in a gallery or if Lascaux II were in Las Vegas rather than 200 metres from the original, I wonder whether we would see them differently. These are points to which I will return later on.

Lascaux was discovered in 1940. Only two years later the Catalan artist Picasso made what some consider an equally stunning artwork, *Bull's Head (Tête de taureau)* 1942 (FIG.06), which is formed from the seat and handlebars of a bicycle. This kind of artefact is known as a found object artwork. *Bull's Head* operates in a similar way to the wall paintings at Lascaux. Both are made from everyday materials – parts of a bicycle, and rock and pigment – but to make sense of Picasso's work we see a bull. I doubt, however, we assume that the artist is about to go hunting. The art critic Roland Penrose (1900–84), one of Picasso's friends, described the work as the artist's most famous discovery, a simple yet 'astonishingly complete' metamorphosis.

We also have Picasso's own words about the artwork as he described it to the photographer George Brassaï (1899–1984) in 1943:

> Guess how I made the bull's head? One day, in a pile of objects all jumbled up together, I found an old bicycle seat right next to a rusty set of handlebars. In a flash, they joined together in my head. The idea of the Bull's Head came to me before I had a chance to think. All I did was weld them together ... [but] if you were only to see the bull's head and not the bicycle seat and handlebars that form it, the sculpture would lose some of its impact.

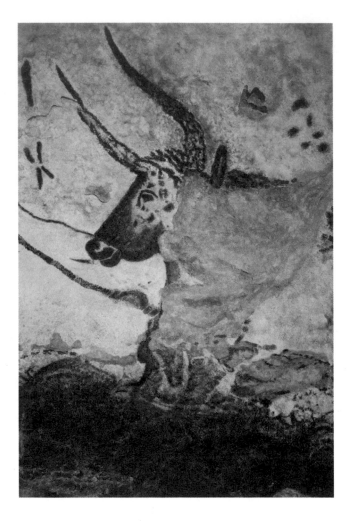

[05] **LASCAUX CAVE PAINTING**

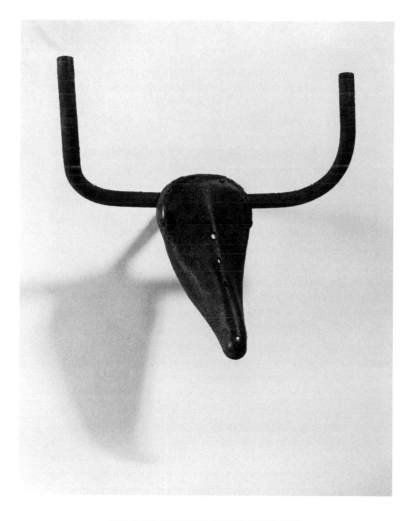

[06] PABLO PICASSO, **BULL'S HEAD** 1942

The artwork did indeed have impact! In 1944, it was displayed at the Salon d'Automne in Paris. The shock caused by the work prompted a demonstration by outraged visitors to the exhibition and feelings ran so high that it was removed from display. Art and outrage are not infrequent bedfellows, but I do wonder if these same protestors gazed in amazement at the newly discovered images on the walls at Lascaux. Here the marks on the stone rely on us regarding them as representations of the natural world, including bulls, and we are very eager to do this. Indeed, the types of animals drawn on the walls have been identified and authenticated as living in the area at that time. Picasso's bicycle seat and handles also make us see a bull, but the artist's sleight of hand in doing this is visible. We remain conscious of Picasso's materials. We know that Picasso saw both bull and bicycle and that he wanted us to see them both too. Perhaps we are more comfortable trying to see what we think the caveman saw. In this way it is easier to believe we are not being manipulated, or 'made to see', when in fact that is just what is happening. It is mineral pigment on stone that evokes a bull. Our cavewoman or caveman and Picasso help us to collapse the space/time dimensions in which we usually encounter art. We can, then, begin to consider how we might do this differently.

This brings me to my second point about how we encounter art and the effect it has on the way in which we see it. Here I return to my observations about the caves at Lascaux, where the spaces have been named as if they were parts of a European building. This makes them seem more familiar to us. We are equally familiar with the spaces of the gallery. No matter how innovative we find the exterior architectural form of galleries and museums, their interiors offer few surprises. Plain walls, regular proportions and top-lighting fulfil our expectations of what is sometimes referred to as the 'white cube'. But these spaces can in fact dislocate art from its original cultural

and temporal context and this affects our viewing of it. Certainly, much modern and contemporary art is at home in these spaces as it was not commissioned for a particular site. Also, the interior and exterior spaces of the gallery offer exciting opportunities and challenges to artists, as we will discover.

In many museums and galleries artefacts are dissociated from their intended function or purpose. For instance, our interest in a Christian altarpiece can focus more on it being an example of a specific artist's work or of a style of art rather than as a devotional image. Indeed, we rarely see a complete altarpiece comprising main, side panels and predella panels. Often these various parts have been sold as artworks in their own right, rather than as fragments, and are scattered across several collections, if not continents. The portability of artworks and their movement between collections and continents impacts on the way Western art is ordered and presented in the gallery. We see artworks that have no context in terms of their original setting and these objects may be assembled in ways that emphasise, for instance, the medium, style period or artist.

When we look at Western art we are usually encouraged to be intrigued by the concept of genius, particularly of the male artist. When asked to name a famous artist many of us might come up with Leonardo da Vinci (1452–1519). After all, he did produce one of the most famous paintings in the world – the Mona Lisa (La Gioconda) 1503–17 (FIG.07) – and it would be remiss of me not to at least mention it. The crowds that stand ten deep in front of the bulletproof glass to glimpse the work are testament to both the artist's and the picture's fame. Perhaps unaware of the consequences of visitor wear and tear at Lascaux, many flout the rules and take photographs of the Mona Lisa, despite the prominent warnings that each flash of the camera can degrade the paint pigments. Some visitors even jump up above

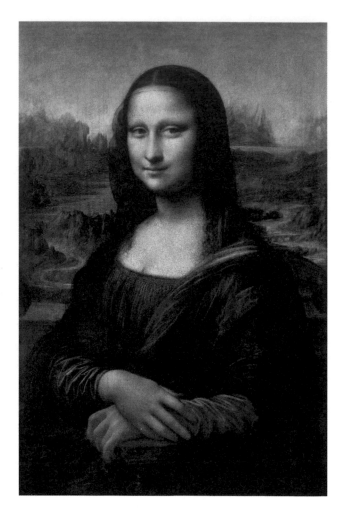

[07] LEONARDO DA VINCI, **MONA LISA** 1503–17

the heads of the throng in front of them to snatch a photograph. The image of an unknown woman with her enigmatic smile has achieved a kind of cult status. I do not know what Leonardo wanted to make us see when he painted the picture, but I think he might be surprised to see our response to his portrait and the way it is displayed in the gallery, let alone the array of key rings, mouse mats and coffee mugs available for purchase in the Louvre shop. The mass reproduction of souvenirs works only to enhance the aura and fame of the original work. If we photograph the *Mona Lisa* she somehow becomes ours, yet, in so doing, we risk her smile fading forever.

Patrons and Artists
—

There are in fact very few paintings by Leonardo. He was also an inventor, scientist and architect, and provides us with one of the first examples of the term 'Renaissance man'. Here, I would like to talk about a particular art historical puzzle, which raises questions about patrons and artists. My story about Leonardo focuses on his picture *The Virgin of the Rocks*, or rather the two versions of it held in the National Gallery, London, and the Musée du Louvre, Paris. The paintings are almost identical and show the Madonna and Christ Child with the infant John the Baptist and an angel in an imposing rock-filled landscape setting that gives the paintings their shared name. The Louvre version is generally considered to be the earlier of the two and dates from around 1483–6; the National Gallery version (FIG.10) was probably painted around fifteen to twenty years later. Both pictures are almost 2 metres high and were painted in oil on panel, although the Louvre version was transferred onto canvas in the early nineteenth century. In the National Gallery collection, there are also two paintings of angels playing musical instruments by members of Leonardo's workshop, which were probably completed between

1490 and 1495. These panels are believed to have been part of the altarpiece for which the two versions of *The Virgin of the Rocks* were intended to be the central image.

The story of this altarpiece explains something about how these elaborate artworks were made. Rather like the *Mona Lisa*, we want to see these works as masterpieces: the product of a creative genius. In fact, Leonardo was only one part in this complex process. His patrons made important decisions about the altarpiece as a whole, including its painted panels, that tell a different story from the one we might expect to hear. The altarpiece was commissioned by the Confraternity of the Immaculate Conception for its chapel that was attached to the church of S. Francesco Grande, Milan. The highly ornate wooden frame for the altarpiece was commissioned separately and in advance of the pictures themselves. In 1480 Giacomo del Maino (before 1469–1503/5) began work on a large wooden altarpiece frame with spaces for paintings and with carvings and decoration, to be placed above the altar of the chapel. It was completed in 1482 and one year later the Confraternity commissioned Leonardo and his assistants, the brothers Ambrogio (c.1455–c.1510) and Evangelista de Predis (c.1440–c.1490), to provide the painted panels. All the various panels of this altarpiece are now framed as if they are separate works of art.

The contract for this work survives and it tells us much about the different values that were placed on this artwork by contemporaries compared with those of today. Leonardo was referred to as the 'master' but it was not clear which of the three artists involved were to paint the various parts of the altarpiece. By contrast, the colouring and gilding, especially of the carved figures on the original frame, are set out in great detail in the contract. The pigments used were expensive. To contemporary eyes these may have had more 'added value' than the hand of Leonardo.

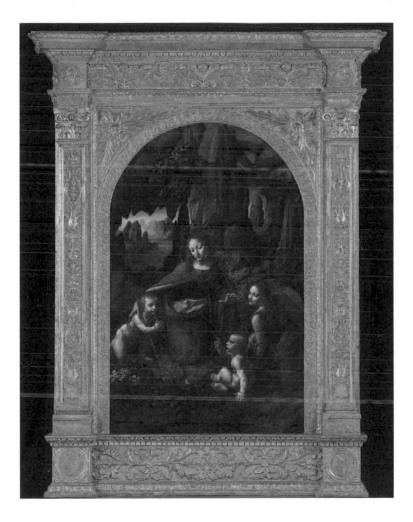

[08] LEONARDO DA VINCI, **THE VIRGIN OF THE ROCKS** 1506–8

We can only guess as to why there are two versions of this picture. It is very likely that Leonardo sold the Louvre version and then painted the second picture in order to fulfil the commission. An altarpiece without a central image would look rather strange and it is not improbable that he was being pressured into meeting his commitments. A contract is a legally binding document, after all. We must not forget that Leonardo had to make a living. The painter starving in a garret for the love of art is a nineteenth-century romantic notion of creativity and 'genius'. This confection turns our heads away from the artist as craftsman, as employee and, not infrequently, as shrewd business operator. Art historical debate focused instead on proving that only one of these works (the Louvre version) could be by Leonardo. However, the need for an original 'masterpiece' was overtaken by close analysis and cleaning of the painting itself. Now both works are accepted as mostly by Leonardo and the fact they are up to twenty years apart helps explain the stylistic differences.

The life of works of art as commodities pre-dates the memorabilia attached to the *Mona Lisa*. The array of altarpieces in their entirety or in fragments in Western galleries is testament to this and *The Virgin of the Rocks* is no exception. In 1576, less than one hundred years after its installation it was removed and in the Chapel of the Immaculate Conception was demolished. Little is known of the picture's subsequent history, except that the version in the National Gallery was purchased in 1785 by the art dealer and antiquarian Gavin Hamilton (1723–98). The picture travelled about England as it passed through the hands of various collectors until it was sold to the National Gallery in 1880 for 9,000 guineas (around £4 million in today's money). The gallery bought the two side panels in 1898. The trade in art and antiquities was brisk in the eighteenth and nineteenth centuries and this helped establish private and national collections of art. Today the auction house and private commercial gallery ensure the continuation of the notion of the artist as genius and art as commodity.

Meaning
—

I would like to stay with Leonardo's *Virgins* to show you how asking a number of questions of the same artwork can deliver a completely different set of meanings and interpretations, some of which may not be immediately apparent to us today. The Confraternity of the Immaculate Conception's contract stipulated the completion date for the frame as 8 December 1483, the Feast Day of the Immaculate Conception. The iconography of *The Virgin of the Rocks* confirms the Christian belief that Jesus was the immaculately conceived Son of God, whose mother was a virgin. This aspect of Christian theology gained traction in the fifteenth century when there was a growing movement to have the conception of Christ's mother, Mary, also acknowledged as 'immaculate'.

The inherently sinless nature of the Virgin Mary was then conferred on her son, who was conceived without the blight of Original Sin, and thus the Immaculate Conception of God. This theological doctrine, for which at one point in the fifteenth century death was the penalty for disbelievers, is narrated using the story of an apocryphal meeting between the infant Christ and his young cousin St John the Baptist. Biography and theology combine in an image now admired for its naturalistic beauty and the mystery behind the two versions of it.

Indeed, the theological aspects of *The Virgin of the Rocks* may not be at all obvious to those not versed in early Renaissance religious debate. Images of the Buddha provide us with an interesting contrast to the narrative representations from the life of Christ (FIG.09). After his death, the Buddha and his teachings were depicted by symbols including a wheel, an empty throne or footprints. The absence of human representations endured for about 500 years, but by the first century CE images began to appear of the Buddha wearing monk's robes.

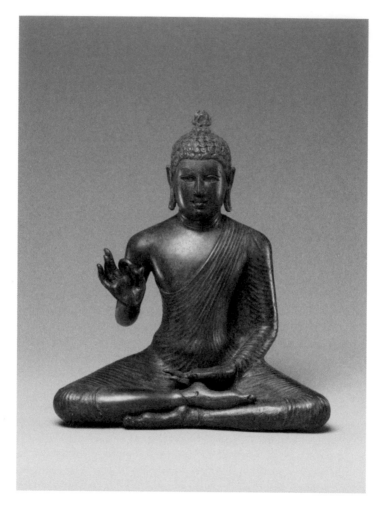

[09] **SEATED BUDDHA EXPOUNDING THE DHARMA** 750–850 CE

He either stands or is seated in the lotus position. His expression is serene and he sometimes holds a begging bowl or makes a gesture that implies fearlessness. Mathura in northern India and Gandhara in present-day Pakistan were two of the main artistic centres. The latter displays an intriguing dialogue with archaic and classical Greek sculpture. Most obviously, this is seen in the depiction of the Buddha's hair as wavy, the treatment of drapery and other items of clothing and, not least, the use of the acanthus leaf as a decorative element. More surprising, perhaps, is the idea of a man-god, which it has been argued crossed over from the mythological figures in Greek art to images of the Buddha. Here the realistic representation of the human form, which we have already seen is characteristic of ancient Greek art, was translated into a kind of idealism of form that expressed the notion of the divine. This visual convention of the Buddha as man and god established the iconographic tradition in Buddhist art. Indeed, regardless of size or materials, which can range from stone to precious metals, images of the Buddha follow a convention of proportions that corresponds to an ideal and represents cosmic harmony.

One of the most popular portrayals of the Buddha shows him meditating while seated in the lotus position. Known as the Dhyana Mudra, the Buddha's eyes are closed, the soles of his feet visible and his hands rest in his lap. Sometimes one hand touches the ground. This symbolises the moment when the Buddha resisted temptation by an evil deity and called the Earth as witness to his resolve to attain Enlightenment. These kinds of images of the Buddha remain constant over time. Perhaps then, not unlike *The Virgin of the Rocks*, we have lost the ability or knowledge to appreciate the subtlety and meaning. I wonder how far this is the case with other artworks. The period eye and our cultural location as viewer are not always the same.

We have seen that bicycle handles can vie for equal importance next to precious metals, and basic mineral pigments can create an illusion as provocative as Leonardo's or Morisot's carefully crafted oils. In recent decades there have been challenges made to what artworks actually are. We see this, for instance, in art as installation, or as staged stories or as ephemeral pieces of performance that explore the possibilities of new media. These kinds of artworks encourage us to think about what we expect art to be made from and what it should do. Moreover, they also raise questions how artworks should be displayed as the authority of the gallery is contested by the artists exhibiting within its very walls.

For several decades installation art has focused on the viewer, placing him or her at the centre of all-encompassing, immersive environments. Recently, a number of contemporary artists have also begun to explore more contained, tableau-like presentations. Pawel Althamer's (b.1967) *FGF, Warsaw* 2007 (FIG.10), both a collaborative sculpture and mobile art gallery, addresses some of these questions. The complete display includes works by several contemporary artists, spread across five of the rooms in Tate Modern. Each of the artworks takes the form of a theatrical or 'staged' presence within the gallery and creates a fictitious space, whether domestic, theatrical, social or institutional. The installation comprises four hardboard wall partitions; a wooden platform; a door with a handle by Monika Sosnowska (b.1972); a found tram window, seat and table; a wooden shelf unit with a journal, various books, catalogues and paper matter, a series of soft sculptural figures, a miniature chair and a sculpture stand; a painting by Jakub Julian Ziolkowski (b.1980); a painting by Wilhelm Sasnal (b.1972); a video on DVD by Artur Zmijewski (b.1966), with DVD player and monitor; a metal sink with a plastic water tank and bucket; a revolving mirror; and a found metal and canvas tent. The walls of *FGF, Warsaw* can be fitted

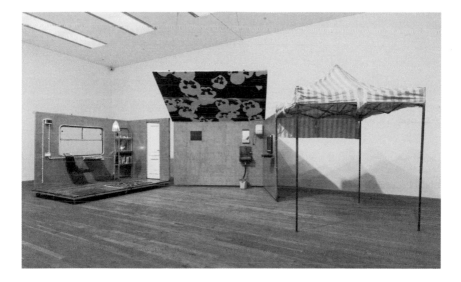

[10] PAWEL ALTHAMER, **FGF, WARSAW** 2007

together to form a transit crate. Created in a spirit of collaboration and exchange, it includes work commissioned by other artists as well as a library and a documentary film that outlines some of the ideas underpinning the work. This kind of work challenges our ideas about the spaces, materials and authorship of art.

Looking

—

Each of the chapters in this book explores different ways of looking that encourage us to see artworks in a number of ways. I begin with a discussion of the relationship between the physicality of artworks and the artists themselves, and provide brief analyses of the various techniques and effects of materials and processes, including paint and pigments; marble and metals; and techniques such as dripping, carving and modelling. We can then discover how different media have influenced what artworks can do.

Art can be both an aid to meditation and a devotional object. I consider the use of art as a specific means of devotion, ranging from the idea of art as a gift in, for instance, marriage pictures, to religious images. This leads me to explore different religious practices and their relationship to artworks. These kinds of uses of artworks extend into the theme of the relationship between art and the mind and our bodily experience of art. Here I think about the role of our imagination in the ways in which we see art and the influence of philosophy and psychoanalysis on our interpretation of artworks. Cross-cutting themes, such as the phenomenological experience of art, also show how our bodily experiences of works cross cultures and time.

Nature in all its complexities is fundamental to our discussion and understanding of art in a global context. A theme that runs through

this brief book is how we can think about art in light of human beings' ever-changing notion of 'nature'. This helps us to consider the formal characteristics of artworks and shows that, while many try to be an accurate portrayal of the world we think we see, others are more preoccupied with abstraction and/or the representation of an idea. The relationship between art and power and its use as a propaganda tool remains a potent topic. This broad category includes portraits and the iconic image, and addresses questions such as the cult of the individual and how his/her power and aura is conveyed and subverted through the visual. I also discuss the power of the artist.

Finally we must not forget that images of the female nude have been a major, age-old preoccupation in Western art. My last chapter extends the survey to look at issues of sex and sexuality. My purpose here is to show that there are common themes in the representation of sex and sexual practices interwoven across a broad geographical and chronological span of human creativity. That said, the intriguing differences in styles of representation and how they are interpreted addresses broader themes, such as the relationship between art and pornography.

This chapter has introduced many of the ideas that help us to explore the form, function and meaning of artworks. There are four main themes to which I will return throughout this book: the chronology of art; the dislocation of art objects from their original location and function; the aura of an artwork; and the cultural location of the viewer.

But perhaps I should give the last word to Picasso:

> As far as I am concerned, a painting speaks for itself. What is the use of giving explanations, when all is said and done? A painter has only one language.

Materials

The artist yields often to the stimuli of materials that will transmit his spirit

ODILON REDON (1840–1916)

Materials

The artist yields often to the stimuli of materials that will transmit his spirit.

Odilon Redon (1840–1916)

When we talk about the materials of art we tend to think about the physical properties of the object. Paint, stone and precious metals all have an effect on the aesthetic of the artwork and our experience of it, but the physicality of an art object is not solely centred on the qualities of its materials. Here I would like to put the artist into the equation, as it is his or her physicality that also has an impact on a work of art: the artist is the intermediary between the materials and the final product. This leads us also to consider the various techniques of using materials in the process of art making, and the changing relationship between artist and artwork.

Something in the Way S/he Moves
—

I would like to begin by looking at movement as the artist's way of mediating between the material and the artwork. In order to explore this I juxtapose two processes of art making that may at first seem culturally, temporally and artistically different. But we will see how they both demonstrate the relationship between artists, materials and artwork, and the importance of movement.

Chinese characters are the oldest form of writing that remains in use today but, according to the noted sinologist Herrlee Glessner Creel (1905–94), Chinese calligraphy 'is not writing in the full sense of the

word'. He is correct; it is much more than that. Thousands of different characters convey both ideas and concepts (ideograms) and words (logograms). Calligraphy, or the art of writing, was the most revered art form in China and its influence spread across East Asia. The elevated status of calligraphy reflects the importance of the word in China; indeed, for over 3,000 years it was considered superior to painting.

Yet, Chinese calligraphy and ink and wash painting are closely related, as they use similar tools and techniques. Known as the Four Treasures of the Study, ink brush, ink, paper and ink stone comprise the essential implements of calligraphy. The simplicity of these tools and materials appears to be matched by the technique by which the ink is applied to the paper and the form of the Chinese characters themselves. Each character is a word or concept and the manner in which it is drawn follows strict rules in terms of the way the ink is applied, the length and direction of the brushstrokes and the form of the character itself. There are no individual flourishes as we might find in, for instance, Western handwriting or indeed the style or technique of a particular painter. Variations in the consistency, amount and thickness of the ink carried by the brush enable the calligrapher to create characters that conform to these rigorous conventions.

The apparent simplicity of the media and technique masks the complexity of the effects that are closely bound to the movements of the artist. Sun Guoting's (646–91) *Treatise on Calligraphy* (687) is one of the earliest on the theory of calligraphy and remains influential. Sun wrote that calligraphy reveals the character and emotions of the writer because Chinese characters are dynamic, that is, they respond to the forces of nature and the energies of the human body as expressed through the act of applying ink to paper. However, these energies are contained within a balanced framework of the media and technique, and the strict conventions of drawing the character.

The subtleties of the gestures through which the ink is applied, the control over the thickness of the ink and the direction and shape of the brushstrokes refer to the morality and correctness of both the artist and the viewer.

We see all of this at play in the hand scroll by Mi Fu (1051–1107), who was active towards the end of the Northern Song Dynasty (960–1127). Mi, one of the leading calligraphers of his time, wrote *Poem Written in a Boat on the Wu River* (c.1100) (FIG. 11) using a suspended arm, working from the elbow rather than the wrist. He entrusted his writing to the force of the brush, giving free rein to idiosyncratic movements that collapsed and distorted the characters.

Calligraphy is not only a means of communication, but also of expressing the artist's inner world in an aesthetic sense. To Western eyes it is sometimes difficult to understand how simple characters drawn in ink using a brush can convey such complexities of meaning, but they are indexical of how the artist mediates between material and artwork.

The flow of ideas and energy from brain to hand is a helpful way of understanding the relationship between materials and art. This might sound rather strange, as we tend to think art has to be made of something – it is a tangible object – but the relationship between the artist, materials and the process or act of producing an artwork is complex and dynamic. Indeed, these themes cut across cultural, temporal and geographical divides. The connection between Jackson Pollock (1912–56) and Chinese calligraphy may not be apparent at first. Indeed, the artist seems to look only forward, not back; when discussing his drip paintings in a radio interview with William Wright in 1950 he remarked:

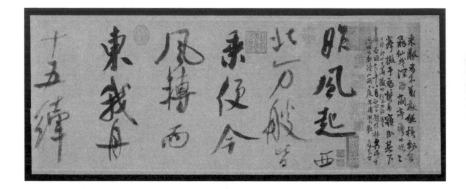

[11] MI FU, **POEM WRITTEN IN A BOAT ON THE WU RIVER** C.1100

All cultures have had means and techniques of expressing their immediate aims – the Chinese, the Renaissance – all cultures.
. . .

I continue to get further away from the usual painter's tools such as easel, palette, brushes, etc. I prefer sticks, trowels, knives and dripping fluid paint or a heavy impasto with sand, broken glass or other foreign matter added.
. . .

My opinion is that new needs need new techniques. And the modern artists have found new ways and new means of making their statements. It seems to me that the modern painter cannot express this age, the airplane, the atom bomb, the radio, in the old forms of the Renaissance or of any other past culture. Each age finds its own technique.

The unconscious is a very important side of modern art and I think the unconscious drives do mean a lot in looking at paintings.

I would suggest that the physicality of the artist as expressed through movement links the two forms of artistic production. In his painting *Summertime: Number 9A* 1948 (FIG.12), Pollock aimed to work directly from his unconscious. The materials and technique he adopted to achieve this led to a radical new process of producing art. He used oil, enamel and commercial paint, which he dripped and poured over a large canvas that measured almost 1 metre x 5.5 metres. To make the most of his technique he abandoned the traditional easel and placed the canvas flat on the ground. This way of working was made possible in part by his large studio. In 1945, Pollock had moved from New York City to Long Island. His studio was a converted barn without heating or lighting. I have visited this studio and the drips of paint that spilled over the edge of Pollock's canvases can still be seen on the

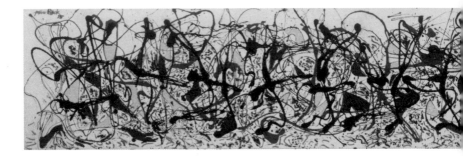

[12] JACKSON POLLOCK, **SUMMERTIME: NUMBER 9A** 1948

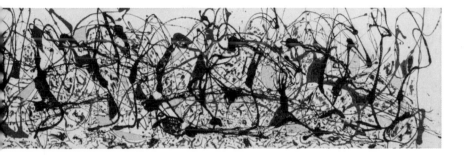

floor. They give a strange echo of the rhythmical movements of the artists employed to produce his work. Equally noticeable are the huge speakers, which formed part of a music system Pollock had set up so that he could listen to jazz while he worked. I sometimes think we can see in *Summertime* the rhythms of the music playing in his studio as it was painted. I am sure the patterns of paint drips that cover the canvas reveal his belief that 'The modern artist ... is working and expressing an inner world – in other words expressing the energy, the motion, and other inner forces'.

Pollock challenged the established, conventional techniques of painting in terms of the materials he used, the way paint was applied and the relationship of the artist to canvas. Instead of looking at the canvas at eye level as it sat on an easel, Pollock stood on it and over it, dripping and pouring paint. He describes this process:

> Most of the paint I use is a liquid, flowing kind of paint, the brushes I use are used more as sticks rather than brushes – the brush doesn't touch the surface of the canvas, it's just above.

The essential difference in Pollock's method of painting is movement – that is, the way artists move as they work with their materials. Minimal movement is required by artists when engaged in easel painting, whether in oil, tempera or watercolour. Discreet gestures of the fingers, hand, wrist or the forearm guide the brush and control the application of paint. By contrast, Pollock used his whole body in a series of controlled movements as he walked up and down the canvas pouring paint onto it. We can unravel the process through which *Summertime* was made as it seems that the first layer of paint Pollock applied was the grey that runs across the canvas. To some people this appears like a frieze of dancing figures. The final layer to be applied was the black, which echoes the movement of the grey across the canvas.

Just as we might hear the jazz playing through the rhythms of these patterns of paint, we might also see the memory trace of the unconscious movements Pollock made with his body as he poured the paint. However, Pollock's movements are as controlled and deliberate as those of the Chinese calligrapher.

The Hand is the Tool of Tools
—

I have borrowed this phrase from Aristotle (384–322 BCE) as it shows how human agency in the production of artefacts has remained a concern across time. The movement of the artist and the physicality of this action help us to consider another aspect of the production of artworks and the influence of materials. Let us think again about Pollock's words: 'My feeling is new needs need new techniques.'

To explore this I would like to travel back in time from Jackson Pollock to the Renaissance. It is easy to forget that every epoch considers itself to be modern. By returning to the Renaissance we can look at a moment when there were indeed new needs and new techniques of making art that met those needs. Private chapels in churches became increasingly common and their walls were decorated using a technique called fresco. Paint is applied to wet plaster which means the artist has to work quickly and has a restricted colour range. Nevertheless, results can be stunning, as we see in Piero della Francesca's work (FIG.13).

One of the earliest texts we have about art practice in the Renaissance is Cennino Cennini's (c.1370–c.1440) *The Craftsman's Handbook* (*Il Libro dell'Arte*), which dates from the opening decades of the fifteenth century. As the title suggests, this was a 'how to do' guide to help artists with their general training and use of materials,

techniques of painting, gilding and so on. One of my favourite pieces of advice is when Cennini discusses the technique of tempera painting, where pigments are mixed with egg yolk (known as the medium):

> When painting the faces of young persons ... use the yolk of the egg of a city hen, because they have lighter yolks than those of country hens.

This certainly reminds us of the organic nature of many artists' materials and the importance of the correct selection of ingredients.

During the Renaissance, artists also began to write treatises and engage in theoretical discourses around the nature and status of art. Indeed, the similarities and differences between poetry and painting encapsulated in the phrase 'ut picture poesis' ('as is painting so is poetry'), from Horace's (65–8 BCE) *The Art of Poetry* (*Ars Poetica*) (c.18 BCE), remained an important touchstone. Artists became intellectuals, included classical subject matter in their repertoire and pioneered new techniques to create the illusion of space and nature. The relationship between the artist and (usually) his materials is germane to this discussion. This change in artistic practice ran alongside a shift in the status of the artist as he emerged from the level of anonymous craftsman to being a kind of 'star' or professional. The elevation in status was helped by writings such as Giorgio's Vasari's (1511–74) *Lives of the Most Eminent Painters, Sculptors, and Architects* (*Le Vite de' più eccellenti pittori, scultori, ed architettori*), initially published in 1550. As the title suggests, this is one of the first books where the biographies of individual artists were considered worthy of interest. Vasari intertwined the life of an artist with his (no women were included) artistic practice: art was explained by the life. Hence our notion of the various stages of an artist's career: we now think readily of early or late works as they are mapped against the biographical narrative.

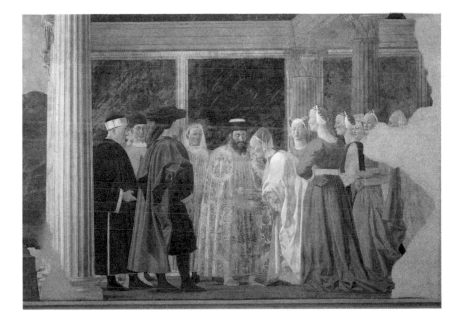

[13] PIERO DELLA FRANCESCA, **ADORATION OF THE TRUE CROSS
AND THE QUEEN OF SHEBA MEETING WITH SOLOMON** (DETAIL) C.1447

The growing artistic self-consciousness of the Renaissance fuelled debates about the 'Paragone' – the dispute over which was superior: painting or sculpture. This was a much-discussed topic in the Renaissance. Here I would like to return briefly to Leonardo, who wrote eloquently on this issue in his many notebooks. He favoured painting over all other arts, including verbal art forms such as poetry, and his critique of sculpture had a personal edge as it was aimed at Michelangelo (1475–1564).

In the Realms of the Senses
—

Leonardo presents the case that painting is the most superior of all art forms because it is based in the senses. Indeed, he suggests 'the eye deludes itself less than any of the other senses'. Therefore, the direct observation of nature is necessary for the process of painting and gives this art form a truthful, scientific quality that provides 'immediate satisfaction to human beings' and in so doing rivals nature itself. Leonardo goes on to give advice, using both words and sketches, about how to paint optical effects such as light and shadow, distance and atmosphere, as well as how to portray aspects of human anatomy, including proportions of the body and facial expressions. Moreover, as the painter works only in two dimensions, but tries to create the illusion of three, this requires more skill and knowledge of the scientific principles of optics and of the rules of mathematical perspective. Leonardo's view is reflected in the following:

> Practice must always be founded on sound theory, and to this perspective is the guide and the gateway.

To explore this further, let us return to the idea of movement, but this time with regard to conventional painting techniques. As I mentioned

earlier, easel painting demands a very distinctive, if restrained, kind of movement from the artist.

I would like to use Leonardo's comments to look at the work of the seventeenth-century Dutch artist Johannes Vermeer (1632–75). Vermeer's canvases were usually quite small. Even so, each work took a long time to complete and this was due in part to the nature of the materials. There were no commercially produced paints available at the time; these did not appear until the mid-nineteenth century. The artist had to prepare his paints each day by grinding the pigments and mixing them with linseed oil. This meant usually only one area of a picture was worked on at a time so as to avoid waste. Moreover, as Vermeer favoured expensive pigments such as lapis lazuli and natural ultramarine, this technique also helped to save money. Typically, artists sketched or blocked out their whole composition tonally, using either only shades of grey or a limited palette of browns and greys. This was the base for the more saturated colours such as red, yellow and blue, which were carefully applied using small brushstrokes.

We see the effects of Vermeer's technique and materials in his picture *Girl with a Pearl Earring* c.1665 (FIG.14), which measures just 44.5 x 39 centimetres. Vermeer's working method most probably was inspired by his understanding of Leonardo's observations that the surface of every object takes on the colour of an adjacent one. This means that even though we might know the drapery is yellow it is painted using a number of colours, so enhancing its vivacity and the effects of light. Indeed, the richness of the colours and the illusion of light make it easy for us to forget we are looking at paint on canvas. In contrast to Pollock, the quality of Vermeer's material – paint – is its invisibility. The materials used and the movement of the artist in applying them remain obscured. Artistic skill is measured by the ability to create the illusion of nature and so in some ways to deceive the senses.

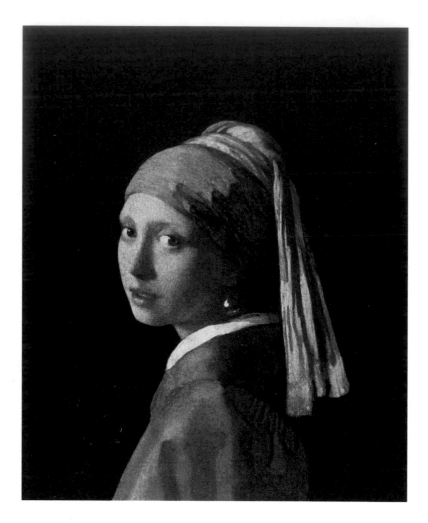

[14] JOHANNES VERMEER, **GIRL WITH A PEARL EARRING** C.1665

Perspiration or Inspiration
—

Importantly for us, Leonardo makes a distinction between painting and sculpture. He asserts that the manual labour involved in sculpting can only detract from the intellectual aspects of this art form. The physical work of carving stone conjures up an image of the artist as tradesman rather than gentleman. He regards the perspiration caused by the exertion needed to hit hammers, chisels and punches as uncouth. The dust caused by these techniques covers the sculptor, giving him a comedic appearance. By contrast, the cerebral process of painting is paramount and the way the artists commands and transcends the limitation of his or her materials is the key to success. In some respects these last remarks bring us back (or forward) to Pollock. I like the trans-historical resonance these two artists have – indeed, Leonardo describes the gentlemanly art of painting as one where the artist could sit at his easel, well dressed, and listen to music (but I suspect not jazz) while linking his or her brain to canvas through the physicality of their actions as expressed through paint. It is only the materials that are different.

Needless to say, not many sculptors would agree with Leonardo's analysis of their art. As I mentioned earlier, the focus of Leonardo's pejorative comments on sculpture in the Paragone was Michelangelo. But Michelangelo was also an accomplished painter and he dabbled in architecture. Vasari saw his work as the pinnacle of artistic achievement in the Renaissance and it is difficult to deny the potency of his iconic image of the creation of Adam, which forms the centre panel of the ceiling of the Sistine Chapel in St Peter's in Rome. Michelangelo did not write a treatise on art, but we do have letters and poems composed by him. We know that he acknowledged both the agency of the artist and materials, as when he spoke of his sculpture:

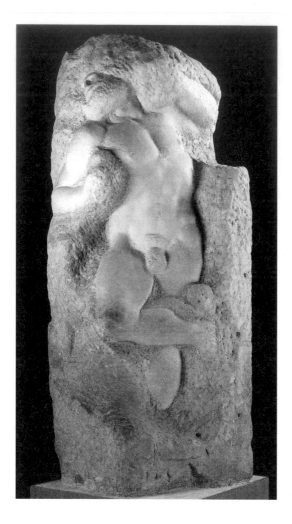

[15] MICHELANGELO, **THE AWAKENING SLAVE** 1525–30

Every block of stone has a statue inside it and it is the task of the sculptor to discover it.

This pinpoints the essence of carving marble – it is a reductive process. Unlike painting, where layer upon layer is added to the picture surface, carved sculpture requires the removal of material. This is an irrevocable process. Michelangelo's own technique was rather distinctive. He chose the blocks of marble himself and proceeded to carve from front to back, rather than gradually chipping away at all sides of the block. Many of Michelangelo's sculptures remain unfinished and these *non finito* works are often regarded as his most enigmatic. The figures seem to be emerging from the stone, or to use the artist's own words:

> In every block of marble I see a statue as plain as though it stood before me, shaped and perfect in attitude and action. I have only to hew away the rough walls that imprison the lovely apparition to reveal it to the other eyes as mine see it.

We can see this in his *The Awakening Slave* 1525–30 (FIG.15), which is a 2.67-metre high marble sculpture. It formed part of the design for the tomb of Pope Julius II (1443–1513), one of Michelangelo's principal patrons, who also commissioned the Sistine Chapel ceiling. Indeed, this figure is one of the 'Prisoners', the series of unfinished sculptures for the second design for the tomb. I like the term 'Prisoners' as it seems to reinforce what Michelangelo is talking about when he describes how he works with his material.

The physicality of the material of sculpture, whether it be marble, metal or wood, is very much part of the finished work. Clearly, there are exceptions, such as when the figure is painted to create the illusion of drapery or flesh, but I would like to stay with the idea of the

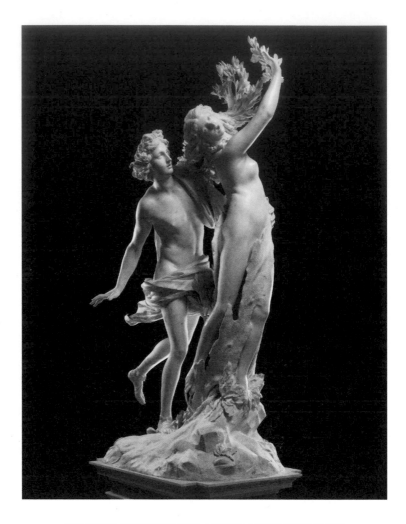

[16] GIAN LORENZO BERNINI, **APOLLO AND DAPHNE** C.1625

relationship between artist and material to explore the ways in which artists both deny and exploit the qualities of their materials.

One of my favourite artworks is Gian Lorenzo Bernini's (1598–1680) *Apollo and Daphne* c.1625 (FIG.16). When I visited it in the Borghese Gallery in Rome, I found it hard to leave the room in which the work stands – its presence is compelling. To my mind and my eyes Bernini transcends the properties of his material and through the physical process of carving transforms marble into flesh, drapery and foliage. The sculpture narrates a moment in the story in Ovid's (43 BCE–17 CE) *Metamorphoses* (c.8 CE). The god Apollo, with the help of Cupid's arrow, is smitten with the nymph Daphne. She rejects his advances and the god chases her, pleading for her to return his love. Finally, the exhausted nymph appeals to her father Peneus:

> Destroy the beauty that has injured me, or change the body that destroys my life.

As she utters these words she is gradually transformed into a laurel tree. The description in Ovid tells us that bark closed around her and her hair became moving leaves; her arms were changed to waving branches, and her feet stopped moving and turned into clinging roots that were fastened to the ground. This moment of metamorphosis, which is full of movement and emotion, is the one that Bernini chose to sculpt. The principal viewpoint is from the side and we can see the reactions of both Apollo and Daphne as the transformation takes place. We are also invited to walk around the sculpture to take in all the details. We see hair turning to leaves, feet being transformed into bark and roots, and Apollo's slightly open mouth as he realises the metamorphosis that is taking place. Most importantly, we are invited to forget this is a piece of stone. It is not just the sleight of hand of the painter that deceives the eye of the viewer into seeing nature.

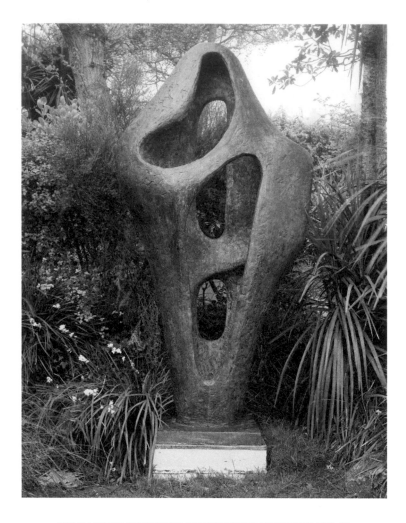

[17] BARBARA HEPWORTH, **FIGURE FOR LANDSCAPE** 1959–60

Nature into Art
—

The slippage between the properties of materials and the artist's engagement with them takes a new turn in Barbara Hepworth's (1903–75) *Figure for Landscape* 1959–60 (FIG.17). This is a substantial presence standing around 2.5 metres high. Hepworth worked in many materials and her art responded to the qualities of her chosen medium. This piece is indicative of the associations between Hepworth's work and nature, especially landscape, and how figures, including this one, both emerged from and were integrated into it. She described the process thus:

> [it] is for a specific landscape. My own awareness of the structure of the landscape ... provides me with a kind of stimulus. Suddenly an image emerges clearly in my mind, the idea of an object that illustrates the nature or quality of my response.

Indeed, the enclosed but rising form suggests the emergence of the work from the landscape – nature transformed into art. The use of enclosed space in the sculpture allows Hepworth to let light into a solid form. She described this process as conveying 'a sense of being contained by a form as well as of containing it'. The process of hollowing out had been a hallmark of Hepworth's carvings in stone. In *Figure for Landscape* we see how this was transposed into a work using plaster, which was then cast in bronze. The particular balance in *Figure for Landscape* is the equation of landscape and figure. The enfolding, vaguely figurative form both opens out to and encloses the landscape around it.

The technique for making *Figure for Landscape* tells us much about the collaborative aspects of this kind of artistic production, where

the artist's intention is mediated through the technical expertise of others. A mould was made by applying plaster to an expanded aluminium armature that had been formed by Hepworth's assistants. The plaster was then worked on by Hepworth and the bronze sculpture was cast from the mould. But the casting of such a large bronze was not always an easy process. The foundries Hepworth usually used were fully occupied with other works for her 1960 Zurich exhibition (Galerie Charles Lienhard). Hepworth remarked 'There remains but one now – a 7 ft [sic] figure – which so far I haven't been able to persuade anybody to do for me, as the foundries are booked up'. Eventually Morris Singer Ltd cast it in 1961. This piece is known as *Figure for Landscape* 1/7, meaning that it was one of seven versions cast. Although each version is slightly different, the reproducibility does call into question the idea of the original work of art. *Figure for Landscape* 1/7 remained in the possession of the artist. The bronze has a green patina as it was placed in Hepworth's garden and, as a consequence, the work has been transformed by its exposure to nature. Inclement weather, leaf mould and birdlime have all taken their toll on the material. Perhaps this is appropriate for such an organic work.

Art against Nature

—

The interaction of artist and materials and the relationship to nature takes a different turn in Antony Caro's (1924–2013) *Early One Morning* 1962 (FIG.18). After he visited America in 1959, Caro moved away from the kind of artistic practice and use of materials that I have discussed so far in this chapter. This trip had a significant effect on his artistic thinking:

> I realised that I had nothing to lose by throwing out History ... America made me see that there are no barriers and no

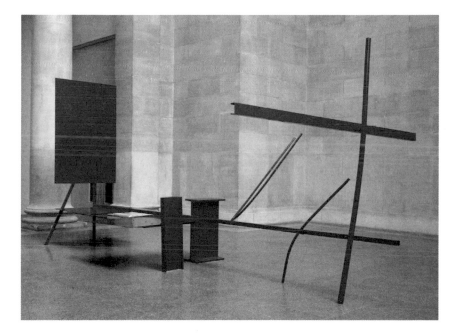

[18] ANTHONY CARO, **EARLY ONE MORNING** 1962

regulations ... There is a tremendous freedom in knowing that your only limitations in sculpture or painting are whether it carries its intention or not, not whether it is 'Art'.

The change in his practice on his return from America expressed his wish 'to get away from all the old sort of work associated with plaster and clay'. Caro began to use materials such as steel sheet and girders, which he then painted so it had

no art props, no nostalgia, no feelings of the preciousness associated with something because it's old bronze or it's rusty, encrusted or patinated.

We see this in *Early One Morning*. It is a light, airy and open composition where Caro created different rhythms and viewpoints by varying the lines and planes of the work. The piece has no fixed viewpoint; instead it unfolds and expands into our space remaining at our eye level through its low horizontal axis. By painting all the elements bright red, Caro made the various parts of the work cohere in the same way as notes come together within a piece of music.

Beyond a Boundary
—

The minimalist sculptor Carl Andre (b.1935) explores new boundaries between the artist and the materials used in the making of sculpture. His practice focuses on the industrial components of everyday production – wood, bricks and metals such as aluminium, copper, steel, magnesium and lead – of which he chooses standard, commercially available units for his sculptural arrangements. He does not alter them – there is no carving, sawing or casting. Instead, they are placed directly on the floor in simple linear arrangements. In this way he brings sculpture back to its

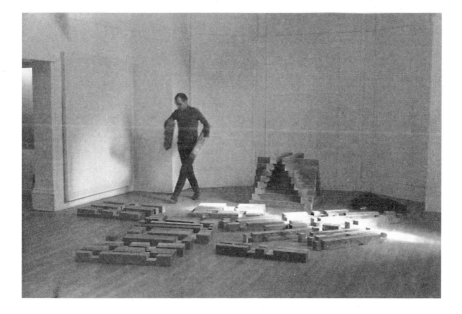

[19] CARL ANDRE BUILDING **CEDAR PIECE** 1964

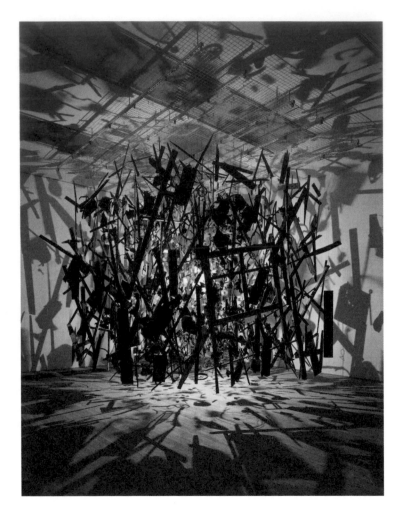

[20] CORNELIA PARKER, **COLD DARK MATTER: AN EXPLODED VIEW** 1991

basic elements: we see the raw materials used in the making of these works. Andre's compositions hug the floor, giving them a horizontal rather than the vertical emphasis we might expect from a piece of sculpture – one that depicts the human figure, for instance. By his choice of materials, Andre has helped to redefine the possibilities of sculpture:

> My ambition as an artist is to be the 'Turner of matter'. As Turner severed colour from depiction, so I attempt to sever matter from depiction.

His compositions made, perhaps most famously, from bricks are intended to defy meaning and militate against art as an expression of ideas. Instead, Andre made the following statement about what he wants to achieve through his materials:

> I would hope my work would be able to convey the same sense of order that let's say a fugue by Johann Sebastian Bach can give ...

> The marks that I have made on canvas or paper have never been convincing to me in the same way as moving a timber or brick from one side of the room to the other.

The artist's movements as he assembles the materials into his composition are part of the work. We remain aware of the physicality of this process as well as of the materials themselves.

Cornelia Parker's (b.1956) work focuses very much on her materials and she uses everyday objects, which, although familiar to us, we may not at first associate with artworks. Parker transforms these in order to examine the nature of matter and to play on private and public meaning and value. This enables her to test and to push out the boundaries of the physical properties of the artwork. Parker has

employed numerous methods of producing art including suspending, exploding, crushing and stretching objects as she explores the full potential of her materials. As she says of her own art practice:

> I resurrect things that have been killed off ... My work is all about the potential of materials – even when it looks like they've lost all possibilities

We see this in her installation *Cold Dark Matter: An Exploded View* 1991 (FIG.20). The main substance of the work is a garden shed, which Parker engaged the British Army to blow up. She chose to re-create the moment of the explosion by suspending the fragments in such as way as to suggest the shed was in the process of being blown up. The sense of momentariness and transience as the shed is transformed from recognisable object into a pile of smithereens is made more dramatic by the light in the centre of the composition (or inside the shed), which casts imposing shadows of the wooden fragments on the walls of the gallery. In this way Parker also introduces the notion of time to an artwork as we feel as if we are looking at something that is in the process of changing – not unlike Bernini's *Apollo and Daphne* (SEE FIG.16).

Bodily Functions/Functional Bodies
—

The lexicon of artists' materials and methods of producing artworks remains an ever-expanding category. In my final example I return to the physicality of the artwork and its relationship with the movement and physicality of the artist. The work of Carolee Schneemann (b.1939) can help us to explore how the artist, the work and the materials may elide. Of her own practice Schneemann remarked:

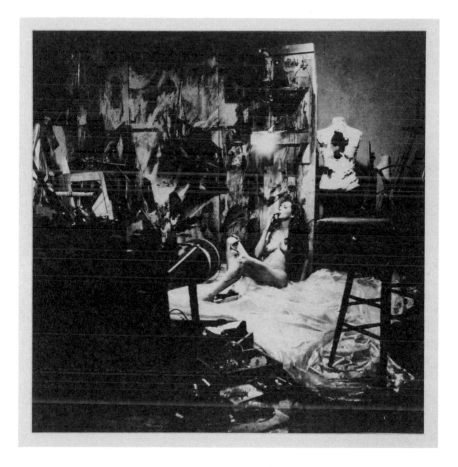

[21] CAROLEE SCHNEEMANN, ONE PHOTOGRAPH FROM **EYE BODY/36 TRANSFORMATIVE ACTIONS FOR CAMERA** (27 BLACK AND WHITE PHOTOGRAPHS) 1963/1973

I take the position that I do not ask anyone else to do what I myself would not do and using myself as subject ... as material [I] want to displace the power and separation of the artist from what's made. In the masculine tradition the director, the producer is always outside of the work because he's above it.

Schneemann works in a range of media and her work often comprises performances by her that were recorded on film or in photographs. Indeed, she thinks of her photographic and body pieces as being based on painting despite appearing to be quite different, superficially at least. She has described herself as a painter who has left the canvas in order to activate actual space and lived time. She sees the brushstroke as 'an event in time' and she has spoken of her performers as 'colors in three dimensions.' Schneemann has also worked in paint and revisited her figurative abstract paintings of the 1950s, where she cut and destroyed layers of paint from their surfaces and re-used them in her photographic work.

In *Eye Body* 1963 (FIG.21) Schneemann created a 'loft environment' filled with broken mirrors, motorised umbrellas and rhythmic colour units. In order to become part of the art, she covered herself in materials including grease, chalk and plastic. She then created thirty-six 'transformative-actions' that were photographs of herself in her constructed environment by Icelandic artist Erró (b.1932). Some of these images were dismissed as pornographic. My interest here is not in these debates, but rather in how in this work the artist becomes the materials and it is her physicality and movement that make the work.

The work of Schneemann and other artists who use performance, video or installation as their materials can seem demanding as it is less familiar to us than works by Leonardo or Bernini. But part of the role of art and artists is to test us and to present new possibilities.

Perhaps, then, we sometimes need to feel challenged rather than comforted when we visit a gallery or a museum. As I mentioned earlier, every epoch thinks of itself as modern, and we saw this quite vividly in the work and words of Jackson Pollock.

I wonder if I should give the last word to the philosopher Friedrich Nietzsche (1844–1900):

> When art dresses in worn-out material it is most easily recognised as art.

Mind

Imagination
abandoned by
reason produces
impossible
monsters

FRANCISCO GOYA (1746–1828)

Mind

> Imagination abandoned by reason produces impossible monsters; united with her, she is the mother of the arts and source of their wonders.
>
> Francisco Goya (1746–1828)

This is the caption to Goya's print *The Sleep of Reason Produces Monsters* (FIG.22), which is part of a series of eighty images published by the artist in 1799. The set is known as *Los Caprichos* (caprices, or follies) and it marks a change in Goya's artistic practice as he moved from courtly paintings to bleaker images that comment on the political and intellectual climate of his own time. In *The Sleep of Reason Produces Monsters* we see a man who is sleeping peacefully, while bats and owls swarm in a menacing fashion around him. An unknown creature sits at the centre of the composition, staring at us and inviting us into the scene. In this way we become part of the image and the monsters share our world as well as that of the dreamer.

One of Goya's aims in this series of prints was to criticise contemporary eighteenth-century Spanish society, especially some of the commonly believed superstitions and religious practices. He saw these practices as lacking reason. For Goya, actions perpetrated without reason could only be evil and corrupt. That is not to say that Goya denied the importance of the imagination, as in his caption for the print he warns that we should not be governed by reason alone. He viewed art as the product of the interaction between reason and imagination. These are both functions of the human mind and these faculties provide the starting point for the exploration of the relationship between art and mind.

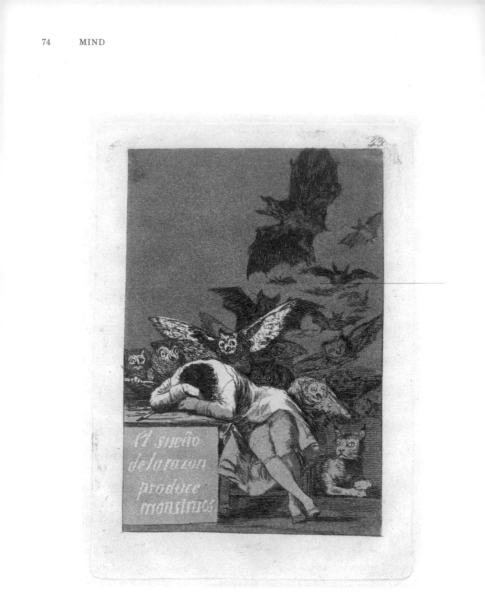

[22] FRANCISCO DE GOYA, **THE SLEEP OF REASON PRODUCES MONSTERS** 1799

I found I could say things with color and shapes that I couldn't say any other way – things I had no words for.

Georgia O'Keeffe's (1887–1986) remark indicates how the relationship of the human mind to art comprises complex categories of engagement with the visual. These cover themes such as the world we think we see and how we see this through/in art. We can think about the relationship of the human psyche to art too – and this can manifest itself in terms of both subject matter and approaches to interpreting art. We may also consider the aesthetic and the ways in which our sensual responses to an artwork take precedence over our reasoned knowledge of it. This is by no means an exhaustive list of the possibilities of the theme of the mind in relation to art, but an exploration of these aspects of art and mind helps to tease out how we use our brains to engage with and understand art.

Let us begin with two apparently very simple images that can help us to start to explore the relationship between art and mind: Ludwig Wittgenstein's (1889–1951) *Duck-Rabbit* (FIG.23) and the Rorschach test blots. Wittgenstein and Hermann Rorschach (1884–1922) enable me to set some important parameters for the discussion between philosophical discourse and psychological investigation.

As a philosopher, Wittgenstein was interested in the ambiguities in language and this also included images as, like words, these can be understood in different ways. Wittgenstein uses the example of a sketch drawing known as *Duck-Rabbit* to illustrate this ambiguity. The image can be seen as either a duck or a rabbit. When we look at the *Duck-Rabbit* and see a rabbit, he argues that we are not interpreting the picture as a rabbit, but rather reporting what we are seeing. Quite simply, we see the drawing as a rabbit. But what happens when we see the image first as a duck, then as a rabbit?

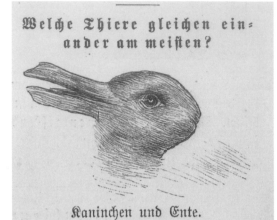

[23] **DUCK-RABBIT**, AS DISCUSSED BY LUDWIG WITTGENSTEIN IN
PHILOSOPHICAL INVESTIGATIONS (1953)

Wittgenstein is exploring the relationship between the external world and the image of *Duck-Rabbit*, which apparently stays the same, while an internal cognitive change takes place. It is the processes that go on in the mind when we look at images, including artworks, that interest me here. We have already seen how these kinds of ambiguities can operate in our discussion of the images of the bulls in the caves at Lascaux and Picasso's *Bull's Head* made from a bicycle (SEE FIGS.5 AND 6). What is important is that sometimes we can see something in a straightforward way – that it is a bicycle seat, perhaps – but, at other times, we notice a particular aspect, so we see it as something else – in this case the head of a bull.

'Seeing' and 'seeing as' are only part of the process of looking at an artwork. Here we rely on a figurative representation that can be seen or interpreted. The post-impressionist artist Paul Gauguin (1848–1903) commented on this:

> Some advice: do not paint too much after nature. Art is an abstraction; derive this abstraction from nature while dreaming before it, and think more of the creation which will result than of nature.

Let us dig a little deeper to see how art relates to our inner selves or, in other words, the ways in which the human psyche, whether that of the viewer or the artist, is manifest in art. To help us think about this I would like to consider what the Rorschach plates can tell us about the relationship between art and the mind. The plates comprise ten inkblots that were assembled by the Swiss psychologist Rorschach. They were especially popular as a means of psychological analysis in the 1960s. Subjects are asked to identify the various inkblots and their responses are analysed in order to identify various mental conditions.

Clearly language is important here as the words used to describe the pictures are key – and these may be culturally determined. Indeed, cultural differences are also an important factor in this method of analysis. People from different continents showed marked differences in their response to some features, while other interpretations remain consistent across cultures. I am not interested here in the debates about the usefulness or accuracy of this test. My point is a more general one about the way we look at and interpret images, how this can be culturally determined and the importance of language in expressing these interpretations. If we look again, for instance, at Jackson Pollock's *Summertime: Number 9A* (SEE FIG.12), the frieze-like run of figures might just be in our minds and may appear quite different to someone from another culture. This becomes even more vivid when we think of this picture in relation to the subtleties of the brushstrokes of the Chinese calligrapher.

Separating Art from the Artist
—

In the previous chapter (PP.36–69) I explored the relationship between the physicality of the art object and the physicality of the artist and how these interacted. In this chapter, through the theme of art and mind, I attempt to dissemble the artwork from the artist, or at least show how they can operate on different levels.

Following on from the discussion of *Duck-Rabbit* and the Rorschach blots, I would like first of all to think about art as being purely about the aesthetic. Goya's distinctions between the rational and the irrational, and between reason and sentiment, bring us back to the eighteenth century. This period is important as, by the middle of the century, aesthetics, that is, a mode of thought based on sensory perception, began to be seen as equal to rational or logical thought. Logic is based

on verbal reasoning, whereas aesthetics is based on the senses – in our case, sight. This goes back to one of the questions I raised right at the beginning of this chapter regarding writing/speaking about visual experience. The language we use to describe art objects can be at odds with our experience of the objects we see.

This is the cornerstone of philosopher Immanuel Kant's (1724–1804) *Critique of Judgement* (1790), which offers an analysis of our ability to make individual judgements about aesthetics and how these underpin the concept of 'genius'. This was seen as a way of assessing the quality of an artwork in terms of its beauty and purpose. Kant proposed that there can be a range of aesthetic taste and also encouraged the view that beautiful objects arouse our sensations in the same way as moral judgements. Therefore, aesthetics and ethics become intertwined and the concepts of genius and taste are intrinsically linked with the moral character of the artist or viewer.

Pinning down aesthetic judgment can be difficult. Indeed, the history of art provides us with many instances where artworks have provoked public outrage. We saw this very clearly, for example, in the initial reaction to Picasso's *Bull's Head*, but now we see his work as having aesthetic value. Did we, the viewing public, simply become used to it as the 'shock of the new' gradually wore off? Kant would argue rather differently that a change in public opinion was in fact due to a reflective process of reasoning, and that this resulted in the expansion of the category of 'beautiful'.

Different methods of representation in figurative art have also tested the relationship between art, outrage and aesthetic judgement. The American-born artist who settled in Britain, James Abbott McNeill Whistler (1834–1903), believed in the primacy of the aesthetic and promoted the view of art for art's sake. He saw parallels between painting

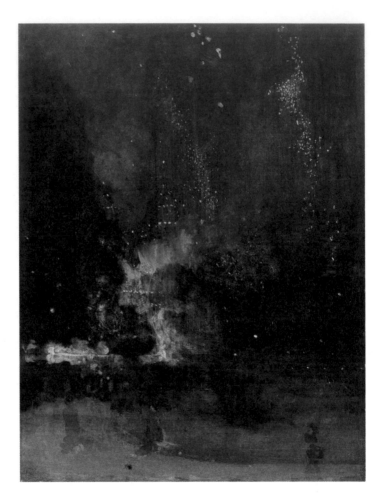

[24] JAMES ABBOTT MCNEILL WHISTLER, **NOCTURNE IN
BLACK AND GOLD: THE FALLING ROCKET** 1875

and music, a theme we encountered in the chapter on materials, and gave his pictures titles to underscore the primacy of tonal harmony, whether aural or visual. Whistler spoke of his work thus:

> Art should be independent of all clap-trap, should stand alone, and appeal to the artistic sense of eye or ear, without confounding this with emotions entirely foreign to it, as devotion, pity, love, patriotism and the like. All these have no kind of concern with it; and that is why I insist on calling my works 'arrangements' and 'harmonies'.

We see can how Whistler expressed these ideas in his work *Nocturne in Black and Gold: The Falling Rocket* 1875 (FIG.24). This picture caused considerable outrage and prompted the contemporary critic John Ruskin (1819–1900) to pronounce:

> For Mr Whistler's own sake, no less than for the protection of the purchaser, Sir Coutts Lindsay [founder of the Grosvenor Gallery where it had been exhibited] ought not to have admitted works into the gallery in which the ill-educated conceit of the artist so nearly approached the aspect of wilful imposture. I have seen, and heard, much of Cockney Impudence before now; but never expected to hear a coxcomb ask two hundred guineas for flinging a pot of paint in the public's face.

Whistler was equally outraged at this criticism and took out a lawsuit against Ruskin in 1877. As part of his evidence he explained his work:

> It is a night piece and represents the fireworks at Cremorne Gardens ... It is an artistic arrangement. That is why I call it a nocturne.

In defence of the price tag of 200 guineas for a piece that took him only two days to paint, Whistler claimed he was charging the high sum 'for the knowledge I have gained in the work of a lifetime'. To the present day viewer Whistler's paintings are accepted and often admired as tonal arrangements and experimentations in the representation of forms.

The Truth in Painting

—

Eighteenth-century aesthetic philosophy found its reprise in the latter half of the twentieth century in the writings of Jacques Derrida (1930–2004). Derrida, a French philosopher, is perhaps best known for his work on the practice of 'reading', where we are compelled to explore the ways in which things that may appear unified are also a series of contradictions. This is known as deconstruction. The implications for our understanding of the relationship between art and mind are quite far reaching. In his book *The Truth in Painting* (1987) Derrida, like his eighteenth-century predecessors, was concerned with the question of whether aesthetic objects (artworks) could be considered as autonomous, possessing their own 'code'. This 'code', in Derrida's view, offers us another way of thinking about art as having a meaning, just as we might consider the social or cultural context of art. It is really an issue of where the boundaries of a work of art lie. This enables us to contemplate the 'inside' and the 'outside' of a work of art, which can be a very helpful technique.

In *The Truth in Painting* Derrida calls into question every aspect of a work of art. The notion of the 'outside' of a work includes, for instance, the frame of a painting or the signature of an artist on their work. But these categories go beyond the work itself to cover museums, archives and the way in which art is bought and sold as a commodity

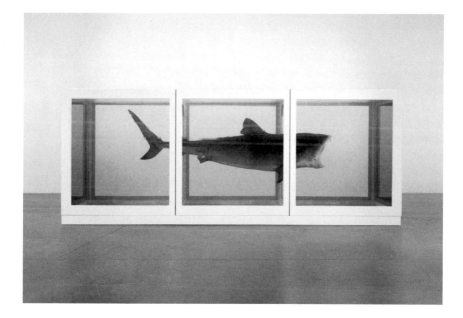

[25] DAMIEN HIRST, **THE PHYSICAL IMPOSSIBILITY OF DEATH IN THE MIND OF SOMEONE LIVING** 1991

on the open market. For Derrida, all these impinge on the 'inside' of the work – the fundamental nature or aesthetic of the work, which is always modified by these external factors. As a result, Derrida sees the inside and outside as merging – both being forms of writing or graphic notation that can be read.

We can see this in the works by a group referred to as the Young British Artists that appeared in an exhibition entitled *Sensation*, which opened at the Royal Academy of Arts, London, in 1995. The artworks were from the private collection of Charles Saatchi (b.1943), a leading publiciser of contemporary art who had had a very successful career in advertising. Some of the works were already (in)famous and included Damien Hirst's (b.1965) shark suspended in formaldehyde, *The Physical Impossibility of Death in the Mind of Someone Living* 1991 (FIG.25); Tracey Emin's (b.1963) tent, *Everyone I Have Ever Slept With 1963–1995* 1995 (SEE FIG.26); work by Jake (b.1966) and Dinos Chapman (b.1962), and by Sarah Lucas (b.1962) (SEE FIG.54), that was sexually explicit. Public outrage was anticipated, prompting the Royal Academy to give this warning to prospective visitors:

> There will be works of art on display in the *Sensation* exhibition which some people may find distasteful. Parents should exercise their judgment in bringing their children to the exhibition. One gallery will not be open to those under the age of 18.

Perhaps unsurprisingly, *Sensation* caused a media frenzy and public outcry. The show was a great financial success as middle England queued up to see the scandal for themselves. As a result of the furore, the monetary value of the artworks also increased. The inside and the outside of the works did indeed merge. It is hard to unpick where the boundaries of art lie in this provocative melee of hype, transgression and commercial enterprise. There is a sort of epitaph

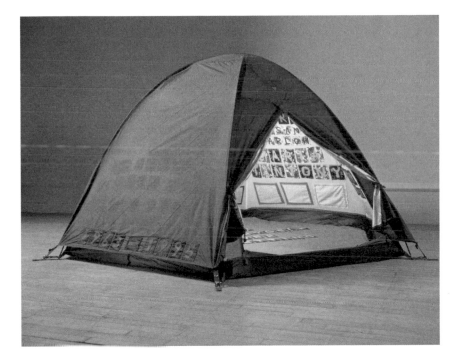

[26] TRACEY EMIN, **EVERYONE I HAVE EVER SLEPT WITH 1963–1995** 1995

to the story of this exhibition: a number of the works displayed at the exhibition were later destroyed in a warehouse fire where Saatchi stored part of his collection. On hearing of the loss of one of their pieces, *Hell 2000*, Dinos Chapman remarked:

It's only art, we'll make it again.

I would like to return via Derrida to Kant's ideas about our cognition of an autonomous aesthetic that is separate from pure reasoning. Like Kant, Derrida's argument for this distinction is an important touchstone of art, where the aesthetic is a legitimate field of enquiry based on sensation rather than reason. The broad historical span of these enquiries gives some indication of their enduring significance for our understanding of art and its processes and meanings. For us, these debates open up possible ways of thinking about art and the mind.

Paul Cézanne's (1839–1906) remark, 'He was an eye but what an eye', refers to Claude Monet (1840–1926), who was one of the leading lights in the group of artists known as the impressionists. Indeed, the movement took its name from his painting *Impression Sunrise* 1872. The work of Monet and the impressionists in general helps us think about the ways in which art and mind can connect and I would like to begin by looking at Monet's technique of painting and his choice of subject matter. We saw in the last chapter how artists such as Vermeer had to prepare paint on a daily basis and this meant their work was largely confined to the studio and influenced how pictures were painted. The impressionists were interested in 'plein air' painting, which meant that the artist left his or her studio to paint outdoors. In the mid-nineteenth century, mass-produced paints available in tubes were invented and these made plein air painting possible. As canvases became smaller so as to fit conveniently inside the lid of a paint box, pictures also

[27] CLAUDE MONET, **THE GARE ST-LAZARE** 1877

changed in size. New techniques enabled artists to engage directly with everyday subject matter and to paint these quickly. The technique of recording ordinary daily life required rapid brushstrokes that exploited the viscosity of the paint. The thickly applied paint known as impasto became a hallmark of the impressionists. In Monet's *The Gare St-Lazare* 1877 (FIG.27), we do not see the seamless finish of Vermeer; instead, brushstrokes remain in evidence suggestive both of the speed of execution and the momentariness of the image. As a result we have pictures that represent fleeting weather effects such as clouds or views of the same object in different light and times of day, as seen for instance in Monet's series of pictures of Rouen Cathedral.

The railway station was very much a feature of modern life in the nineteenth century and it caught Monet's attention in a number of his works. What interests me most in *The Gare St-Lazare* is the way the plumes of steam as they rise from the trains are suggested only by dabs of paint. The viewer is required to complete the image. Our minds make sense of the brushstrokes and turn them into trains, steam and ironwork. But I wonder what we would we see if we did not know what a railway station looked like?

Let us go back and consider the ways in which Kant can help us to understand the relationship between our minds and art, especially how and why we see or judge something to be beautiful. For Kant an artwork is beautiful insofar as it prompts intellectual activity, known as reflective judgement, which is based on the senses. As such, it has nothing to do with thinking about the specific properties of an object – that is, the scientific process of empirical observation. Rather, judgement is about determining if something is beautiful. Importantly for us when thinking about art, the beauty the artwork arouses is not the object itself. Instead, it is the process of ordering – the way in

which the artwork represents an object that exceeds any empirical notion we have of it. As the French poet Stéphane Mallarmé (1842–98) remarked, 'Paint not the thing, but its effect.'

Delightful Horror/Sublime Delight
—

I want here to think a little more about Kantian aesthetics as it helps us to understand how art interacts with our minds. Kant's concept of the sublime is unlike beauty. In some ways beauty limits an art object as it is a quality involving its form or appearance. By contrast, the sublime is primarily a quantity because it hints at the formless, that is, the absence of limitation. Our imagination is overwhelmed by the immensity of what is to be represented. As a consequence, we feel wonder and awe instead of making a judgement of beauty. The concept of the sublime can help us to understand the impact of J.M.W. Turner's (1775–1851) *Snow Storm: Hannibal and his Army Crossing the Alps*, exhibited 1812 (FIG.28).

Turner is often considered one of the forerunners of the impressionists. I am always a little wary of these kinds of claims, as I doubt Turner knew what was going to follow in the future and it is easy for us to look back and see patterns through history that are only of our own making.

This picture shows not only an interest in the accurate depiction of weather but also in the emotional impact of nature. This is sometimes referred to as the sublime, where the viewer is overtaken with a sense of emotion prompted by the extreme nature of the scene being depicted. A comment in the newspaper *The Examiner* on 7 June 1812 gives us some idea of how Turner's contemporaries received the work:

[28] JOSEPH MALLORD WILLIAM TURNER, **SNOW STORM:
HANNIBAL AND HIS ARMY CROSSING THE ALPS** EXH.1812

This is a performance that classes Mr Turner in the highest rank of landscape painters, for it possesses a considerable portion of that main excellence of the sister Arts, Invention ... This picture delights the imagination by the impressive agency of a few uncommon and sublime subjects in material nature, and of terror in its display of the effects of moral evil.

The writer goes on to praise the way that Hannibal and his army were 'represented agreeably to that principle of the sublime which arises from obscurity', and then comments on the weather effects:

An aspect of terrible splendour is displayed in the shining of the sun ... A terrible magnificence is also seen in the widely circular sweep of snow whirling high in the air ... In fine, the moral and physical elements are here in powerful unison blended by a most masterly hand, awakening emotions of awe and grandeur.

Psychoanalysis
—

The relationship between artist and artwork became closer in the twentieth century. The American artist Edward Hopper (1882–1907) remarked, 'Great art is the outward expression of an inner life in the artist, and this inner life will result in his personal vision of the world.'

The twentieth century – especially the opening decades – witnessed a growing interest in the human mind and this facilitated ways of thinking about art in a completely different way. Psychoanalysis is the study of the unconscious mind and was championed by Sigmund Freud (1856–1939). He used methods such as free association and dreams as a means of exploring the human mind. His ideas are now quite familiar

to us – a slip of the tongue is often called a Freudian slip – and so it is hard for us to imagine how new and revolutionary Freud's ideas must have been at the time. Freud described the human self as comprising the id – that is the unconscious mind – and the ego – the conscious mind and the term with which we are perhaps most familiar.

Psychoanalysis allows us to think about meanings in art that run parallel to those the artist intended when the work was made. This is important, as psychoanalysis is another method that enables us to separate the art from the maker and to evaluate our responses to the work. We can also use this method of analysis to investigate the internal processes of the artist's unconscious mind through his or her art practice.

Metamorphoses
—

I would like to stay with the relationship between art and psychoanalysis for the time being. The work of the surrealist artist Salvador Dalí (1904–89) provides us with a helpful way into this discussion. In his painting *Metamorphosis of Narcissus* 1937 (FIG.29), Dalí explores the Greek myth of Narcissus from Ovid's *Metamorphoses* (c.8 CE). I chose this work as it gives us the opportunity to examine the relationship between art and mind on a number of levels. First of all we can consider the surrealists, who were a group of artists interested in the complexities of the human mind and the representation of the subconscious. We can also think about the event itself, which is the transformation of one thing into another. On PP.57–8 we came across a story from Ovid in Bernini's *Apollo and Daphne* (SEE FIG.16). Here again we are invited to see flesh turn into wood, albeit that the sculpture is made from stone. On a different level these two elements combine and fold into the process of 'seeing as'.

[29] SALVADOR DALÍ, **METAMORPHOSIS OF NARCISSUS** 1937

In this painting Dalí reinterprets the myth of the beautiful youth Narcissus. Narcissus loved only himself, and his vanity and self-obsession led him to break the hearts of many lovers. As a punishment for this the gods allowed him to see his own reflection in a pool of water and to fall in love with it. Once Narcissus discovered that he could not embrace the object of his desire he died of frustration. In a fit of remorse the gods immortalised him as the narcissus (daffodil) flower. The story also gives a name to the personality trope of narcissism.

Dalí chose to depict the precise moment when metamorphosis takes place. We see the image of Narcissus, which is suddenly transformed into a hand, rising out of his own reflection. The hand is holding an egg or a bulb from which will be born the new narcissus – the flower. Beside it can be seen a stone sculpture of the hand. This fossil-like version of the hand is holding a blown flower. It is a deathly echo of the image of the living Narcissus that narrates the part of the story when he dies. In the background of the picture Dalí also shows us Narcissus before his transformation. We see him posing on a pedestal looking down on himself admiringly.

Both the technique of painting and the method of representing the subject allow us to investigate the relationship between art and mind in a number of ways. Dalí was fascinated by the mental conditions of hallucination and delusion, and the double images present in this story were an ideal vehicle for exploring these. Things both are and are not what they appear to be. For instance, the hand is also the body of Narcissus and his flesh is also stone. We can rationalise the different elements in the picture but at the same time they defy reason. Indeed, this was the first surrealist work to represent and interpret an irrational subject.

Dalí made this work entirely in accordance with the paranoiac critical method; he explained this as being a 'spontaneous method of irrational knowledge, based on the critical-interpretative association of the phenomena of delirium.' To heighten the (sur)realism of the image and highlight the hallucinatory effect, Dalí used a meticulous technique that he described as 'hand-painted colour photography', giving a hyper-real appearance to the image and this kind of aesthetic. Dalí published a small book, *Metamorphosis of Narcissus* (1937), comprising a poem about the myth and a colour image of his painting. He also included comments on the picture, which help us to understand what is happening:

> If one looks for some time, from a slight distance and with a certain 'distant fixedness', at the hypnotically immobile figure of Narcissus, it gradually disappears until at last it is completely invisible.

In other words, by observing visually, Narcissus turns to stone in our minds, although the image stays the same.

This work brings us back to Freud and psychoanalysis, as in 1938 Dalí met Freud in London through a mutual acquaintance, Stefan Zweig (1881–1942). To introduce himself and his work to the psychiatrist, Dalí brought his painting *Metamorphosis of Narcissus* with him together with a magazine article he had written on paranoia. Freud seems to have been suitably impressed, noting in a letter to Zweig, 'it would be very interesting to explore analytically the growth of a picture like this'. We know also that Dalí was pleased to have shown the painting and to have explained its meaning to Freud. In itself this event has a surreal quality about it. Imagine Dalí arriving at the meeting carrying this picture and presenting it as a kind of oversized, bizarre calling card. I wonder if the artist sat on the famous couch while he spoke about his work?

Ambivalence
—

Susan Hiller (b.1940) trained as an anthropologist but rejected the 'scientific' nature of her discipline. She was attracted to art practice as it offered a way of fantasising about ordinary objects rather than trying to fit them into a neat quasi-factual narrative. Hiller was influenced by the visual language of minimalism, conceptual art and surrealism, which she combined with her anthropological methods of examining artefacts. To explore her ideas, she developed a process of collecting and cataloguing, presentation and display, through which everyday ephemera become artworks. These artefacts invite us to look at the inherent contradictions in our own cultural milieu, as well as the individual and collective unconscious and subconscious.

Hiller is concerned with our irrational experiences as manifest, for example, in the workings of the subconscious. These experiences might include the supernatural, the surreal, the mystical and the paranormal, that is, phenomena that defy logical or rational explanation. She juxtaposes the rational 'scientific' methods of taxonomy, collection, organisation, description and comparison through which we might expect an explanation to be found with the irrationality of the experience the artefacts represent. In this way she avoids assertions such as 'true' or 'false', 'fact' or 'fiction' in relation to these experiences. When we view these artworks the lines between our rational and irrational experiences become blurred.

We can stay with Freud and the concept of psychoanalysis in art as my example from Hiller's work is *From the Freud Museum* 1991–6 (FIG.30). It comprises personal materials collected by the artist, such as mementos, relics and other memorabilia, similar to a display in an anthropological museum. The artefacts are in boxes and are grouped together in a kind of physical manifestation of fragments

[30] SUSAN HILLER, **FROM THE FREUD MUSEUM** 1991–6

of memory. The combinations of the objects suggest some kind of meaning but the viewer is also invited to add their own interpretation to the installation. As such, the work remains open to continuous and shifting readings.

From the Freud Museum explores the slippage between the known and the unknown, and between dream and reality. Hiller commented:

> Sigmund Freud's impressive collection of classical art and artefacts inspired me to formalise and focus my project. But if Freud's collection is a kind of index to the version of Western civilisation's heritage he was claiming, then my collection taken as a whole, is an archive of misunderstandings, crises, and ambivalences that complicate any such notion of heritage.

In this way we can see how Hiller investigates the historical and cultural variance inherent in artefacts and art objects based partly on the way we view them and partly on the meanings we ascribe to them. At the same time she enables us to examine the unconscious nature of our culture, and to explore the margins of our collective psyche that operates within established societal norms.

Strangely Familiar
—

Artworks can sometimes be strangely familiar. By this I mean that a work can appear to represent the world we know but there is something unreal about it too. Freud referred to this as the *Das Unheimliche*, or 'Uncanny' – that is, the opposite of what is familiar. It is without doubt that the Uncanny can refer to a broad category of artistic production, not least because what is familiar to one viewer may be alien to another. I would like to explore the Uncanny through the work

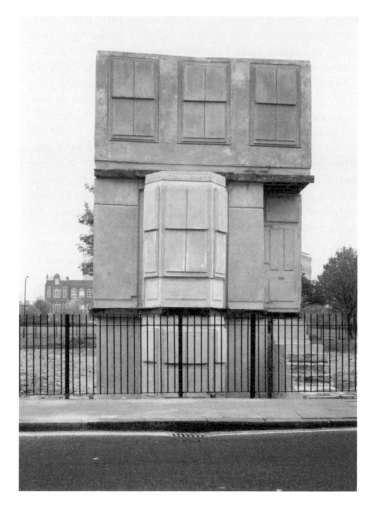

[31] RACHEL WHITEREAD, **HOUSE** 1993

of the sculptor Rachel Whiteread (b.1963). *House* 1993 (FIG.31) was a concrete cast of the inside of an entire Victorian terraced house in East London. The address was 193 Grove Road and all the houses in the street were demolished by the local authority. *House* was exhibited where this building had once been located. The work presents us with an inverted representation of the original, which has been denatured by transformation. The familiar elements of the house perform in space in unexpected ways: the fireplaces protrude outwards from the walls, whereas the doorknobs are recessed hollows. Most strikingly, the architraves that would usually delineate the tops of the walls cut an incision around the whole work. Whiteread explores the space that these objects do not normally inhabit. The controversy over *House* was amplified when the local authority decided to demolish the work early in 1994, only a few months after its completion. In an interview about her work Whiteread described herself as a realist rather than a symbolist. She went on to say that her decision not to give works a title was to avoid making the reading of the work very specific. Nevertheless, she did acknowledge that many viewers do read symbolic significance into her work but continued:

> I'm not responsible for how people respond to works, but you can't dictate how people respond to works.

This brings us back to Freud and the Uncanny, which is derived from the German *Das Unheimliche* with its base word *Heimlich* (concealed, hidden, in secret). Freud asserts that the Uncanny is what unconsciously reminds us of our own id, our forbidden and thus repressed impulses perceived as a threatening force by our super-ego. In this way we project our own repressed impulses onto things that appear strangely familiar. We see Narcissus as both flesh and stone, alive and dead. Everyday objects lose their familiarity when reconfigured through their means of display. And spatial incongruities

create a kind of cognitive dissonance. Our experience of the uncanny is paradoxical as we are both attracted to and repulsed by an object. So, here we return to Goya's uncanny monsters that reside in our minds, but perhaps we should remember the words of the painter Paul Klee (1879–1940):

Art does not reproduce the visible; rather, it makes visible.

It should actually be completely and utterly the language of our feelings, our frame of mind, indeed, even of our devotion and our prayers

CASPAR DAVID FRIEDRICH (1774–1840)

Devotion

> Despite what even many artists appear to believe, art is
> not and should not be merely a skill. It should actually be
> completely and utterly the language of our feelings, our frame
> of mind, indeed, even of our devotion and our prayers.
> Caspar David Friedrich (1774–1840)

The relationship between art and devotion reveals an array of
visual expressions of human feeling, belief and loyalty. These are
complex categories that cross cultures and religions. Devotion can
be expressed in figurative and abstract forms, through patterns and
calligraphy and in a vast array of media. In this chapter I explore the
different aspects of art and devotion as seen in the ways in which art
can express attachment to a person or loyalty to a cause, religious
piety or belief.

My principal interest is to look at how art communicates different
sentiments and beliefs, and the range of artistic/visual narrative
conventions that are used to convey these various manifestations of
devotion. First of all, I would like to step back and think more broadly
about the range of meanings of the word devotion. This is a useful
way of examining how art can express feelings and belief and it helps
us to understand the diversity of practices used in the production
of devotional and religious art from across temporal and cultural
geographies. I shall set up some comparisons to see how devotion in
all its complexities is depicted in art, and to show how these kinds of
images operate in the public and the private realm, how they arouse
our sentiments and feelings, and how they tell stories.

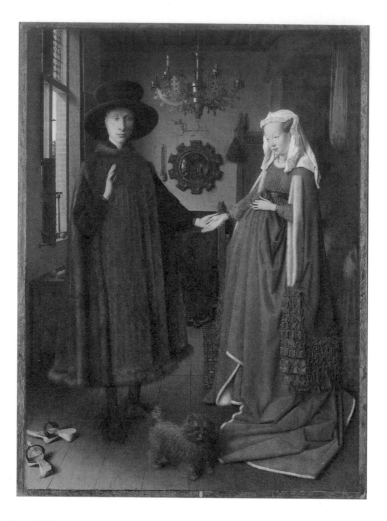

[32] JAN VAN EYCK, **PORTRAIT OF GIOVANNI ARNOLFINI AND HIS WIFE** 1434

All You Need is Love
—

Let us begin with art as the expression of devotion – or more specifically the attachment of one human being to another. My first example is a 1434 double portrait by the early Netherlandish artist Jan van Eyck (c.1380/90–1441) (FIG.32). It is a small panel picture measuring 82 x 60 centimetres and so was probably meant only for private enjoyment, perhaps in the home of the patron. The sitters are usually taken to be Giovanni di Nicolao Arnolfini and his wife Giovanna Cenami. Arnolfini was a member of an Italian merchant family from Lucca who lived in the Flemish city of Bruges, which was a trading centre at that time. The couple are shown in a well-appointed interior, which may be their bedroom. Of particular note is the convex mirror in the centre of the composition that reflects a figure that might be the artist or may be meant to represent us, the viewer. There is some debate about whether this painting commemorates their marriage. Indeed, the picture is sometimes called the *Arnolfini Marriage* or *Arnolfini Wedding* and some art historians have suggested that the painting is a visual rather than a written form of marriage contract. If this is the case, Van Eyck may well have been a witness as we can see his ornate signature documenting his presence – 'Johannes de eyck fuit hic 1434' (Jan van Eyck was here 1434) – in the centre of the painting above the mirror. An alternative suggestion is that Giovanna Cenami is dead and that this is a posthumous picture commemorating both her and the couple's marriage.

To many of us this picture might seem rather remote and removed from our own experience. Whatever the debates about the meaning and symbolism, it is clear that this is a portrait of a couple and we are invited to view, if not witness, their devotion to each other. But there are important points of contact with today and with the broader practices of devotional art. It is helpful here to think about the picture in terms

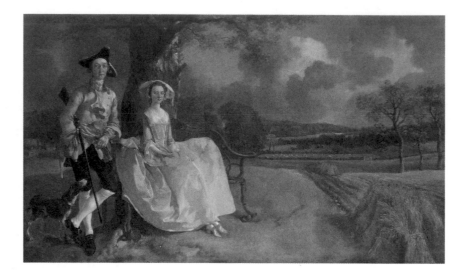

[33] THOMAS GAINSBOROUGH, **MR AND MRS ANDREWS** 1750

of it being a fifteenth-century equivalent of a present-day wedding photograph. We are perhaps more familiar with the way in which these kinds of images are carefully staged: for instance the wedding rings are emphasised and the stance purposely constructed to ensure the correct body language between the happy couple. Alternatively, the image might include the cutting of the wedding cake or the pose framed by the church entrance in order to add a narrative thread.

The *Arnolfini Marriage* is just as carefully staged. The mirror reflects two figures in the doorway. One may be the painter himself, especially as he signed the picture to say that he was there. Perhaps we are also involved as we are invited to think we are meant to be the other figure entering the room? Arnolfini raises his right hand as he faces us, which we could see as a greeting. We are engaged in this work and it is as if we are walking into the privacy of the Arnolfini marital home and witnessing for ourselves the devotion of this couple. Indeed, the picture is rich in symbolism that helps us to understand what is being represented. The most familiar symbol is probably the little dog, denoting loyalty. There are other, more curious, signifiers of devotion, for example the single candle in the left-front holder of the ornate six-branched chandelier, which may be the candle used in traditional Flemish marriage customs. The cherries present on the tree outside the window may suggest love. Van Eyck was an early pioneer of the technique of painting in oil. This allowed him to explore his interest in the effects of light, which is exploited to the full in this picture, for example in the gleaming brass chandelier.

The *Arnolfini Marriage* helps to introduce how the use of illusionism, symbolism and narrative contribute to the making of devotional art. Indeed, the private, intimate nature of this picture provides an important point of contact between secular and religious art. Its small size recalls the devotional images that were popular especially during the Middle

Ages and the Early Renaissance that were made for personal use and were often portable.

The portrait tradition that celebrates marriage can be found across the history of Western art. Before the easy recording techniques of photography, these kinds of pictures were sometimes also an on-going document that could be updated. We see this in Thomas Gainsborough's (1727–88) *Mr and Mrs Andrews* 1750 (FIG.33). This portrait celebrates the marriage of Robert Andrews of the Auberies and Frances Carter of Ballingdon House, near Sudbury, Suffolk, in November 1748. If we look closely, we see that the depiction of Mrs Andrews is unfinished and the underpainting around her lap is visible. Gainsborough probably left it like this so it would be easier to add a child at a future date. It was neither unusual for artists to 'make room' for future members of the family nor to add sitters posthumously. *Mr and Mrs Andrews* is set outdoors, which is significant because the marriage not only joined together two people but also adjacent land and property. Some commentators have noted that this picture is more about devotion to social and financial advancement than the celebration of a marriage.

Portraits of couples, not least the *Arnolfini Marriage*, found a reprise in David Hockney's (b.1937) work in the 1960s. Some of the couples he painted were imaginary; others were friends of the artist shown in their home surroundings, such as *Mr and Mrs Clark and Percy* 1970–1 (FIG.34). Mr and Mrs Clark are the dress designer Ossie Clark (1942–96) and the fabric designer Celia Birtwell (b.1941) at whose wedding Hockney had been best man. Percy is one of their cats. The composition is deceptively simple. As with the *Arnolfini Marriage*, we are invited into the picture by Mr and Mrs Clark, located in their bedroom, who look out at the artist and us. We see symbols such as the lilies, which connote purity, and the cat, whose independent

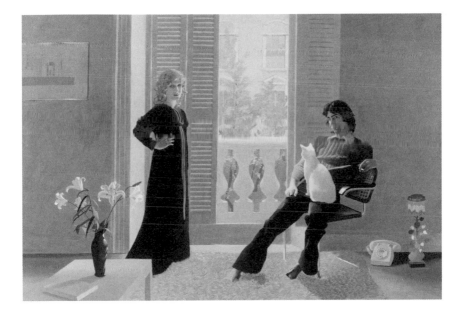

[34] DAVID HOCKNEY, **MR AND MRS CLARK AND PERCY** 1970–1

nature parodies the fidelity of the Arnolfinis' dog. Hockney further subverts the traditional marriage picture in the pose as, in contrast to *Mr and Mrs Andrews*, we see Mr Clark sitting and Mrs Clark standing. The light comes in from the window in the centre of the room hitting us straight in the eyes and puts the figures against the light (known as *contre jour*), which is technically quite difficult to paint. Hockney worked from drawings and photographs and remarked that he wanted to:

> achieve ... the presence of two people in this room. All the technical problems were caused because my main aim was to paint the relationship of these two people.

Indeed, the two figures are separated by the window, hinting at a relationship that was not to last – and this turned out to be true.

Blood is Not Thicker than Water
—

The Oath of the Horatii (Le Serment des Horaces) (FIG.35) by Jacques-Louis David was painted in 1784. In contrast to the *Arnolfini Marriage* this painting speaks of a very different kind of devotion and was intended for a public audience. The painting enjoyed instant acclaim from those who saw it on display in the Salon – the most important annual, public exhibition of art in France. It remains an impressive work; whenever I visit the Louvre, the large canvas measuring 3.33 x 4.5 metres stands out from the embarrassment of riches held in the Denon wing of the museum. Despite its imposing presence, I have to admit I find the kind of devotion this work aims to inspire to be rather chilling.

David depicts a scene from a Roman legend about two cities that were at war in the seventh century BCE: Rome and Alba Longa. The conflict had been chronicled by ancient writers including Livy (59 BCE–17 CE)

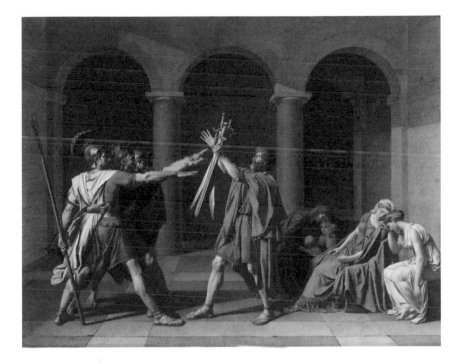

[35] JACQUES-LOUIS DAVID, **THE OATH OF THE HORATII** 1784

in *Ab Urbe Condita (From the Founding of the City*, I 23–7). In order to end the war it was agreed that three brothers from a Roman family, the Horatii, would fight three brothers from a family of Alba Longa, the Curiatii. Although it is not described in the written sources, David chose to imagine the moment when the Horatii affirm their willingness to sacrifice their lives for the good of Rome and salute their approving father who holds their swords out for them.

This story emphasises allegiance to the state rather than to family or social caste, or indeed to any religious faith, and the celebration of this kind of loyalty appealed at this time in France. Questions of fidelity and duty were paramount in the period running up to the French Revolution and they were explored in literature as well as art. This picture remains one of the defining works of this kind of sentiment. In the painting the three brothers express their solidarity in their devotion to Rome above all else, before they enter into battle. With the blessing of their father they are willing to lay down their lives for patriotic duty and as such they are symbols of the highest virtues of Rome. David wanted to inspire the viewer to show the same level of devotion to France.

In complete contrast, the women of the family are depicted in poses that reflect their grief at the possibility of their menfolk dying. The feelings and sentiment in this picture become more complicated as the two families are related by marriage. The women and children appear stage right and represent three generations of both the Curiatii and Horatii that are intertwined. We see the sister of the Curiatii, who is the wife of the eldest of the Horatii, and the sister of the Horatii, who is betrothed to one of the Curiatii. Behind them stands the mother of the Horatii holding her grandchildren, who are related to both families.

The simple composition, rather like those found on a Roman sarcophagus or a Greek vase, comprises life-size figures arranged in a frieze-like fashion in a large empty space. Indeed, this picture is regarded as one of the finest examples of a style known as neoclassicism. As the name suggests, this style in art and architecture drew its inspiration from ancient Greece and Rome and was very popular in the late eighteenth and early nineteenth centuries in Europe and America. Here David presents us with a model marriage of classical subject matter and ideals that are expressed in a neoclassical idiom.

David explores the effects of lighting and pose to express the various feelings of the characters in the story. The singularity of their devotion to the state is expressed through the posture of the Horatii. They have energetic bodies that are emphasised by their straight lines and the vivid colour of their drapery helps underscore their strength and determination. By contrast, the women's bodies are curved and their drapery is muted, implying a very different set of emotions and feelings about the oath the brothers are in the process of taking with their father.

Indeed, this is hardly a story of happy families as, after the defeat of the Curiatii, the only surviving Horatius returned home to find his sister cursing Rome over the death of her fiancé. He was so horrified by her curse that he put devotion to state before devotion to family and killed her. It is possible that David had initially intended to depict this episode as he produced a sketch drawing of it, but perhaps he decided that it was not the best way of advocating unequivocal devotion to the state and public duty. In case you are curious about the ending to this sorry tale, Horatius was arrested and tried for the murder of his sister. However, he was acquitted after his father intervened to say that given the circumstances his daughter deserved her death.

[36] EDWIN LANDSEER, **THE OLD SHEPHERD'S CHIEF MOURNER** 1837

Carl Gustav Jung's (1875–1961) comment that 'What is essential in a work of art is that it should rise far above the realm of personal life and speak to the spirit and heart of mankind' may well apply to the story of the Horatii but might equally be used to understand Sir Edwin Landseer's (1802–73) *The Old Shepherd's Chief Mourner* 1837 (FIG.36). This picture epitomises the nineteenth century British obsession with the trappings of death, which Landseer combines with his use of animals as a means of expressing emotion. This mixture of pathos and realism enjoyed wide appeal. The painting was exhibited at the Royal Academy in 1837 and proved a great success, particularly as an engraving, which sold widely in the following year. We might now dismiss this kind of work as being too sentimental and the sort of thing we might find on a greetings card (but do we disregard the many such cards that use images by other artists – Van Gogh or a Japanese print for instance?). Whatever the feeling the work now evokes in us, Landseer's picture employs many of the techniques we have seen used by Van Eyck (SEE FIG.32) and David (SEE FIG.34). We see the representation of devotion emphasised by a dog as a symbol of fidelity, and we have a narrative that tells us of commitment and devotion beyond the grave.

Landseer may seem a strange bedfellow of art historical giants such as Van Eyck and David. He might seem an even more unlikely bridge between two parts of this chapter, but he does provide a link between art that represents devotion and art that inspires devotion.

Inspiring Devotion
—

Approximately one quarter of the world population is Christian. Yet, despite its global presence, Christianity remains closely identified with Western culture and there is no doubt it has been a substantial

influence on the development of art in the West. The representation of devotion in Christian art is not straightforward as there are many varying conventions and rules according to different sects of the religion. It is not my intention here to explore these in depth. Rather I prefer to think about three themes that help us understand what these pictures do to inspire devotion: they can make the viewer think deeply about faith and belief; they can teach the viewer about religion; they can inspire the viewer to feel love, fear or respect for Christianity. As an anonymous fifteenth-century commentator remarked:

> Images are ordained to stir one's affections and heart to devotion, for often one is more stirred by sight than by hearing or reading.

Icons

—

Icons are one of the earliest forms of Christian art representing the saints, Christ and the Virgin, as well as narrative scenes such as the Crucifixion of Christ. Nowadays icons are mainly associated with Eastern Orthodox Christianity, which maintains the traditions of Constantine and the Early Church. From their beginnings in Byzantium, icons were made from a range of media (SEE FIG.03), including marble, ivory, gemstones, precious metals and enamel. Generally small in size and therefore portable, these icons were often private devotional images. Larger versions, produced in fresco or mosaic, decorated the walls of churches. Whatever the size or materials, it was believed that the act of viewing allowed direct communication with the sacred figure(s) represented. In this way prayers were addressed directly to the holy figure in the image. The Virgin, individual saints or other figures were portrayed according to distinct conventions. Saints could be identified by the colours of their drapery – for instance, St Peter wears blue and

gold. Alternatively they are portrayed with an artefact, known as an attribute, which usually refers to their martyrdom – for example, St Catherine is usually shown holding the wheel on which she died.

One of the most frequently found icons of the Virgin is known as the Virgin Hodegetria, which first appeared in around the twelfth century. In this representation of Christ and his mother, the Virgin cradles the Christ Child in her left arm and points towards him with her right hand. The Hodegetria image was extremely popular in icons produced for worshippers who followed the Eastern Orthodox sect of Christianity, but it was also very influential for representations of the Virgin and Christ Child in Western Europe during the Middle Ages and Renaissance.

The Hodegetria c.1230 (FIG.37) by Berlinghiero of Lucca (fl.1228–1236) shows the Byzantine influence on religious art in Italy in the trecento (the thirteenth century). The key element here is that the Virgin presents her son to the viewer rather than holding him as one would a small child. Indeed, the Christ Child appears more like a small adult than an infant. We can also see the Byzantine influence, for instance in the way the Virgin's head is tilted to one side, in her facial features, not least her almond-shaped eyes, and in her elongated fingers. Images sometimes included symbols that prefigure the death of Christ, for example coral beads or a goldfinch. Most striking perhaps is the luxurious nature of these images with their gilding and the use of expensive pigments such as lapis lazuli – a shimmering blue made from semi-precious stones.

This kind of image began the tradition of representations of the Virgin and child that became one of the mainstays of Christian art in the West. The images became increasingly realistic as artists studied from life for the figures (including infants) and from the actual landscape

[37] BERLINGHIERO OF LUCCA, **THE HODEGETRIA** C.1230

for the settings. In the first chapter we saw, for instance, Leonardo's interpretation of this in his *The Virgin of the Rocks* (SEE FIG.08), where his studies from life and inclusion of identifiable plants typify the preoccupation with nature during the Renaissance. His use of chiaroscuro (light and shade), a technique that he pioneered, also helps to create a more natural looking image (see also the chapter on materials, PP.36–69).

The use of narrative in devotional art takes another turn in the series of images known as pictures cycles that began to appear especially in Italy during the Renaissance. Patrons paid for the construction and/or decoration of private chapels. Sometimes the altarpiece or the picture cycle that decorated the chapel included a representation of the patrons, known as a donor portrait. This secured the connection between devotional gift and the patron. Frequently, these gifts were made as a way of atoning for sin (often that of usury). It was believed that the connection between donor and devotional image helped this process as the saints depicted could mediate between the donor and God. Many of these private chapels contained picture cycles that narrated stories from the Bible. Usually they were painted in fresco, applying pigment directly onto wet plaster, which reduced the range of luxurious materials that could be used and meant images were painted more quickly. As a result, the gilded, jewelled icons of earlier times were replaced by more naturalistic images.

We see this for example in Masaccio's (1401–28) fresco *The Tribute Money* 1425 (FIG.38) in the Brancacci Chapel (Cappella dci Brancacci), which is in the Church of Santa Maria del Carmine in Florence. Pietro Brancacci commissioned the building of the chapel in 1386, but it was his descendant, Felice Brancacci, who commissioned the frescoes in around 1423. Most of the picture cycle was painted by Masaccio whose work signals a radical departure from the existing pictorial conventions. He employed the recently discovered rules of perspective

to create the illusion of space and portrayed his figures as if they were three-dimensional objects rather than flat stylised icons. Masaccio also explores how these kinds of pictures can best tell a story. All the elements come together in the representation of the miracle of *The Tribute Money* as told in the Bible. According to Matthew (17:24–27) Christ is asked by the tax collector to pay a tax or tribute for the temple. In response Christ orders St Peter to fetch a coin from the mouth of the first fish he can catch and to use this money to pay the tax collector. The miracle is portrayed as a human event, which nevertheless has an explicit didactic purpose.

The three stages of the story are united in the picture and this technique is known as continuous narrative. Masaccio uses space to help us follow the sequence, which begins in the centre then moves stage left and finally stage right. In the centre of the composition we see Christ receiving the tax demand and instructing St Peter about what to do; the miracle is perhaps symbolised by Christ's gesture to St Peter. Peter, on the left, is taking a coin from the fish; on the right, Peter tenders the coin to the tax collector. The choice of subject, which is quite unusual for picture cycles or indeed devotional art of any kind, appears to be related to the establishment in Florence of income tax, known as the Catasto, at the same time as the Brancacci Chapel was being decorated.

The pursuit of nature and naturalism in Christian art did not always meet with approval. In some ways the reaction to the work of Caravaggio (1571–1610) reminds us of the discussion on p.79 about the 'shock of the new' and the way Kant argued that shifts in public opinion about art were due to reasoning, resulting in the expansion of the category of what we find beautiful or indeed acceptable and appropriate.

Giovanni Pietro Bellori (c.1616–1690) looked back on Caravaggio's life when he was writing his biography as part of his *The Lives of*

[38] MASACCIO, **THE TRIBUTE MONEY** 1425

Modern Painters, Sculptors and Architects (Le Vite de' pittori, scultori et architetti moderni, 1672). This study followed in the tradition established by Giorgio Vasari a century earlier, which we came across on p.48. Bellori remarked:

> He [Caravaggio] was satisfied with [the] invention of nature without further exercising his brain.

Clearly Caravaggio's work was not to his biographer's taste, as it transgressed from naturalism into the kind of stark realism that reminds us that characters from the Bible were human beings. Saints were depicted using real people as models, often with 'warts and all', rather than shown as idealised figures.

In 1599 Caravaggio was contracted to supply two pictures for the Contarelli Chapel in the church of San Luigi dei Francesi in Rome. *The Calling of Saint Matthew* (FIG.39) and *The Martyrdom of Saint Matthew* were an immediate sensation. Caravaggio's tenebrism (a more intense type of chiaroscuro) added drama to his pictures. At the same time his acutely observed realism heightened the emotional intensity of his work. We can see this in *The Calling of Saint Matthew* where the figure of St Matthew shows a man who is far from idealised in his appearance. At the moment of his conversion to Christianity, a beam of light enters the picture from the direction of a window to create dramatic effects.

Theatricality is often identified as one of the main characteristics of the seventeenth-century style of art referred to as baroque. This usually comprises stage props such as angels or parting clouds, lots of movement and bright colours. Such exuberance is frequently associated with the Counter Reformation, when the Catholic Church vigorously challenged the growing popularity of Protestantism.

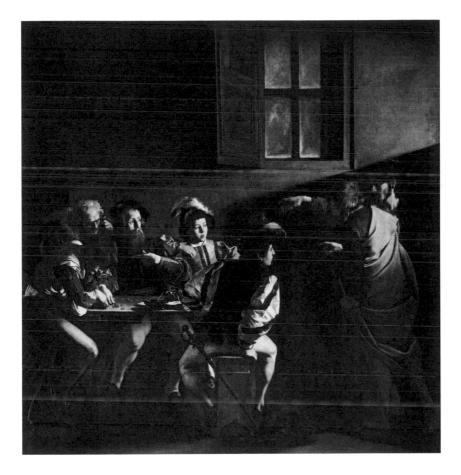

[39] CARAVAGGIO, **THE CALLING OF SAINT MATTHEW** 1599–1600

By contrast, Caravaggio uses only light and shade to narrate the conversion of St Matthew, yet I would suggest his work is as theatrical as any other representation. The drama is palpable through the lighting and the artist's use of real-life models – holy figures had never been depicted like this before. Unsurprisingly, contemporary opinion about Caravaggio's work varied greatly. He was denounced for his insistence on painting from life, without drawings, but was also hailed as a great artistic visionary. Despite his own misgivings, Bellori recorded that

> The painters then in Rome were greatly taken by this novelty, and the young ones particularly gathered around him, praised him as the unique imitator of nature, and looked on his work as miracles.

The predominance of figurative art in the Western Christian tradition has perhaps established a set of expectations of what we want to see in religious devotional art. However, I wonder if this may desensitise us to the ways in which art from other faiths inspires or represents devotion.

> The ability to believe is our outstanding quality, and only art adequately translates it into reality. But when we assuage our need for faith with an ideology we court disaster.
> Gerhard Richter (b.1932)

Here the contemporary German artist Gerhard Richter makes an important link between art as an expression of faith or devotion and the problems that can arise when art is used as an expression of religion. Richter's own standpoint is that of a professed atheist with 'a strong leaning towards Catholicism'. Through an example from his own work, we can see how the 'disaster' to which Richter alludes can come about. Richter's oeuvre includes abstract and photorealistic

[40] GERHARD RICHTER, **COLOGNE CATHEDRAL STAINED GLASS WINDOW** 2007

painted pieces, as well as photographs. He deliberately uses a range of styles and media and this is no more apparent than in his work in glass. In 2002 Richter was commissioned to design the stained glass for a window in Cologne Cathedral (FIG.40). The design, which measures over 113 square metres, took five years and comprises an abstract collage of 11,500 randomly arranged pixel-like squares in seventy-two colours. It is a stunning kaleidoscopic image of light and colour that any viewer can find invigorating, if not inspiring. Yet, the cardinal of the cathedral, Joachim Meisner (b.1933), boycotted the unveiling ceremony. He had wanted a more conventional figurative representation of Christian martyrs – preferably those from contemporary times. Interestingly for us, Meisner is noted to have remarked that Richter's window would fit better in a mosque or other prayer house.

Richter's window straddles the divide between art and design. And this is not without its controversies. As David Hockney remarked, 'Art has to move you and design does not, unless it's a good design for a bus.' I do not want to take issue with David Hockney. I can understand the point that he, as a fine artist, is making – but as someone who has spent a long time studying and thinking about buildings I would beg to differ. It is hard not to regard architectural design as moving; in the context of this chapter it can also inspire devotion. We can see this, for instance, in the design of St Peter's in Rome. The vast scale of the church is impressive and the arms of the church in the form of the curved colonnades come out to greet us. However, Hockney's remark is helpful when we begin to consider how religious devotion is represented visually in cultures and faiths other than the Western Christian tradition. Christian viewers are familiar with a range of representations of, for example, the Crucifixion or Christ and the Virgin Mary. Moreover, figurative narrative art of events from the Bible is accepted and sometimes described as being 'the Bible of the illiterate'.

[41] **OTTOMAN BLUE TILE** C.1530–40

Perhaps then we do not initially appreciate the subtlety of gesture, pattern or colour that may be the prompts for devotion found in other faiths and traditions.

My aim in the final part of this chapter is to look at the art (or indeed the design) of another of the major global faiths in order to expand our understanding of the relationship between art and devotion. Around a fifth of the world's population follows Islam and, like Christianity and Judaism, it is one of the great monotheistic religions. We have seen how in Christian art representations of holy figures are used as prompts for religious contemplation. In the first chapter we also saw the interconnection between representations of the Buddha and traditions in Western art. Islamic art is rather different, as it does not focus on the human figure. Instead, the decorative arts and design such as architecture, calligraphy and ceramics are the principal art forms. Surface decoration is a common aesthetic thread through these forms of artistic production. We can see this in the example of architectural tile work. Up until the fifteenth century, animal figures and purely geometric motifs were applied to tiles, but later blue and white tiles became increasingly popular, especially with the Ottomans, and we are perhaps more familiar with these.

This kind of design spread across the Ottoman Empire and we see it in mosques and palaces from that time. A single tile is an attractive object but we must remember that this was only one of many hundreds or thousands of pieces that were assembled next to each other to create a visually stunning interior (FIG.41). I have visited a number of mosques, especially in Turkey, and I am constantly taken aback at the ways in which the art of design is used to create impressive interior spaces.

This chapter has taken us on quite a journey, from the meticulously recorded interior of the Arnolfinis' bedroom to the decorative arts found

in stained glass and ceramics. The visual intensity of all my examples, whether figurative or not, underscores the way these artworks operate as symbols or reminders of our beliefs. We do not know what each of the artists we have looked at thought about the work they produced, but I wonder if Gwen John (1876–1939) speaks for many of them in her remark:

My religion and my art are my entire life.

Power

To me art
is a form
of manifest
revolt, total
and complete

JEAN TINGUELY (1925–91)

Power

To me art is a form of manifest revolt, total and complete ...
with Dada I also have in common a certain mistrust towards
power. We don't like authority, we don't like power.
Jean Tinguely (1925–91)

The view expressed by Tinguely speaks as much of the autonomy of
the modern artist as of the relationship between art and power. This is
a broad category that includes various kinds of art forms and media,
for example portraiture and photography, and addresses questions
such as the cult of the individual and how his/her power and aura are
conveyed and subverted through the visual. Tinguely's remarks point
us towards the complementary themes I would like to discuss in this
chapter: the power of the artist and of the patron, and the power of
art and art as a manifestation of power.

Art and Ideology

—

In order to understand the relationship between art and power it is
helpful to consider how art operates as an ideology. This also shows
us another way of thinking about art compared with Kant's idea of
the aesthetic that we came across in the chapter on mind. The early
nineteenth-century German historical philosopher Georg Wilhelm
Friedrich Hegel (1770–1831) was one of the first writers to articulate
the relationship between art and ideology. While I do not wish to
tackle Hegelian philosophy or its influences here, some background
to the ways in which art objects can operate and their perceived
function is useful. I would like to focus on the fact that Hegel placed

great emphasis on looking at the broader context of art, and indeed its history and evolution. He also thought it important to look very carefully at the objects themselves in order to fully make sense of them. In doing this Hegel introduces the idea that art is not solely about connoisseurial values, that is, the appreciation of what things look like. This is key not least with art and power, as it moves art away from the importance of the aesthetic and helps us to dissociate the artwork from both the artist and/or patron to see how it functions in its own right.

Hegel prompts us to think about the idea of progress and how society is represented in the art forms it produces. This was part of his concept of the 'spirit of the age', where art is a barometer of the social, political and cultural milieu in which it is made. We have come across this on PP.112–17, in J.-L. David's *The Oath of the Horatii* (SEE FIG.35), where the classically inspired story expressed in a neoclassical style was meant to represent those social and political values of France at the end of the eighteenth century that were drawn from ancient Rome.

This also introduces the idea that there are many ways of seeing art depending on your class or cultural viewpoint. Leading on from this is the notion that the ideology of art is all to do with the manipulation of power, as art can make us think about ourselves in a certain way. It is the power of art and the art of power, through the coming together of the aesthetic, the spirit of the age and distinctive ideologies, that interest me here.

The twentieth-century artist Edward Hopper remarked that:

> A nation's art is greatest when it most reflects the character of its people.

This certainly also holds true for the eighteenth century as it was a period in which, according to the cultural historian E.P. Thompson (1924–93):

> The ruling-class control in the eighteenth century was located primarily in a cultural hegemony, and only secondarily in an expression of economic or physical (military) power.

Thompson underscores the power of art to define social class and the importance placed on cultural objects in the expression of power. This is evident in the fashion for collecting artefacts from ancient Greece and Rome, which became must-have items for the elite. In this way these objects were part of the ideology of a certain class. If you appreciated them, understood them and, best of all, were wealthy enough to own some of them, you belonged to this social group. We have already come across this kind of international currency in art objects in the first chapter, in the discussion of the provenance (the history of the ownership of the artwork) of Leonardo's *The Virgin of the Rocks* (SEE FIG.08) where the version in the National Gallery had been bought by the art dealer and antiquarian Gavin Hamilton in the eighteenth century.

The Grand Tour enabled those who could afford it the opportunity to purchase artefacts and other cultural objects and so augment their own social prestige and standing. On their return to Britain, Grand Tourists displayed their collections in their country houses, which were in themselves statements of the power of the elite. The Grand Tour portrait is a distinctive art form that relates to this kind of expression of social and cultural power. The Italian artist Pompeo Batoni (1708–87) was a renowned portraitist who recorded many Grand Tourists, for example, *Francis Basset, 1st Baron de Dunstanville and Basset (1757–1835)* 1778 (FIG.42). This picture shows the future baron in Rome on

[42] POMPEO BATONI, **FRANCIS BASSET,**
1ST BARON DE DUNSTANVILLE AND BASSET 1778

the Grand Tour, with the Castel Sant'Angelo and St Peter's Basilica in the background. He is depicted surrounded by the sort of collectibles that Grand Tourists brought back home. Some are real objects; others are fictitious, such as the ancient Roman altar on which he is leaning, an invention that helps the composition of the portrait.

The provenance of the picture gives us an insight into some of the broader political contexts for the relationship between art and power. Batoni painted the portrait in Rome but it was seized by the French, who were at war with Britain, while it was being shipped back to England on board the British frigate HMS *Westmorland* in 1779. The French sold the work to Charloe III of Spain (1716–88) and so it is now in the Prado in Madrid.

Therefore, art, or its re-appropriation, shows us another way in which it can reflect or express power. We see this in many of the collections in museums and galleries where the loot of military campaigns is part of the displays that underscore a nation's power and pre-eminence. Indeed, Batoni's picture was recently included in an exhibition that reassembled the artworks looted from the *Westmorland*. We tend to forget how far works of art have travelled, either through being cultural loot or saleable commodities, and that they can be signifiers of power in so doing. I shall return to this point later.

It is important to remember that the appropriation of culture is not only a Western phenomenon. If we look, for instance, at the art of the Incas, the race that dominated pre-Columbian South America for about 300 years before the Spanish invasion, we see the considered adoption of the art (and indeed other skills) of the tribes they had conquered. This is particularly evident in the decorative ceramics and gold works where the assimilated artistic forms and practices became symbols of the right to rule.

[43] PETER PAUL RUBENS, **THE DESTINY OF MARIE DE' MEDICI** 1621–5

Batoni's Grand Tour portrait helps us to understand the social and cultural potency of art objects, and indeed art making and collecting. I would like to think more about the role of art in the creation and projection of identities, especially of those in authority. We came across this on PP.108 10 when we looked at the portrait of *Mr and Mrs Andrews* (SEE FIG.33), which seems as much about the couple's social supremacy as about commemorating their marriage. My example here is an extraordinary work of art comprising no fewer than twenty-four separate canvases that all focus on the same individual: Marie de' Medici (1575–1642), the second wife of Henry IV of France (1553–1610). Marie herself commissioned the work, known as a picture cycle, from the artist Peter Paul Rubens (1577–1640) in 1621. The canvases, which were completed in less than two years, were designed to decorate the interior of the Luxembourg Palace in Paris (FIG.43). All but three of them depict events from Marie's life. The others are portraits of Marie and her parents.

By any standards this was a highly ambitious project with the sole purpose of immortalising the life and achievements of Marie. Rubens had a burgeoning reputation as a court portrait painter and his efficient studio meant he had the capacity to produce such a grandiose series of pictures. We have already seen how contracts between artists and patrons can help us to understand pictures when we looked at the two versions of Leonardo's *The Virgin of the Rocks*. Here, perhaps surprisingly, the contract between Rubens and Marie is remarkably light on detail, especially for such a large-scale series. It concentrates on the number of pictures in the cycle that should be dedicated to the praising of the queen's life, and is notably far less specific when it comes to the portrayal of her husband. The contract does, however, stipulate that Rubens was to paint all the figures, but it is likely his studio executed the background and other details.

[44] DIEGO VELÁZQUEZ, **EQUESTRIAN PORTRAIT OF PHILIP IV** 1635–6

The picture cycle raises some interesting questions about the relationship between art, the projection of identity and power. First of all we must remember that, as a woman, Marie was quite unusual in being the focus of such artistic attention and indeed of being the patron of this type of project. The task of creating twenty-one pictures about anyone is hard enough, but the usual (masculine) narratives of power, for example victory in battle, allegories of judicious rule or allusions to the divine right to rule, were not available to Rubens. Moreover, Marie was not always a popular queen and had been tainted by some hints at court scandal. Here, again, the classical world was adopted as a device through which to express power and authority. In many of the pictures mythical gods and goddesses surround Marie, so bolstering her image and reputation. In some canvases she almost appears to be deified.

Reference to the classical world finds a reprise in another art form that also expresses power: the equestrian portrait. The monumental decorative scheme of the Hall of Realms in the Buen Retiro Palace in Madrid provides us with a provocative comparison to the Marie de' Medici cycle. The scheme was devised and overseen by one of the most powerful politicians in the seventeenth-century Spanish royal court, Count Olivares (1587 1645). Just as the Marie de' Medici pictures celebrated their eponymous subject, these portraits were intended to affirm the glory of the Spanish monarchy when in fact it was in a period of decline. The well-established court painter Diego Velázquez (1599–1660) was commissioned to produce the works, and between 1635 and 1636 he painted five equestrian portraits: Philip III (1578–1621), Queen Margarita (1584–1611), Isabella of Bourbon (1603–44), Philip IV (1605–65) (FIG.44), and Prince Baltasar Carlos (1629–46). Velázquez also depicted Olivares in a similar mode, which was unusual because equestrian portraits were normally the preserve of royalty. Ironically, this work is perhaps the most successful of the

series in conveying authority. I would like to concentrate here on the portrait of Philip IV as it helps us to understand how these images convey supremacy.

The equestrian portrait dates back to classical times and is seen, for instance, in the bronze sculpture erected in 175 CE of the Roman emperor Marcus Aurelius (121–180 CE). The height (over 4 metres) is achieved in part by the emperor being seated on a horse and this is an effective way of conveying power and a kind of divine grandeur. These techniques of representation were adopted by Renaissance artists in both sculpture and painting. Velázquez makes reference to this long-standing tradition, imbuing his sitter with the authority of antiquity and the impressive illusion of height. Indeed, the canvas is very large, measuring over 3 metres square. We see Philip in profile, which helps to conceal his facial features, most notably his hereditary Habsburg jaw. We also see evidence of Philip's equestrian prowess, as the pose of his horse is a form of classical dressage or 'airs' above the ground. Philip IV is master of his horse and of his kingdom.

Velázquez's portrait of Philip IV was intended to underscore the ruler's right to rule and this was achieved with the use of discreet references to established traditions in state portraiture and some artistic sleights of hand. The kind of state portraiture we have seen in both the Marie de' Medici cycle and the Buen Retiro pictures presents iconic images of power rather than true likenesses of the sitters. For artists such as Rubens and Velázquez it was probably wise to flatter their patrons. This is especially so if we bear in mind the remarks of the society portraitist John Singer Sargent (1856–1925), who recorded the social elite in the late nineteenth century:

> Every time I paint a portrait, I lose a friend.

Size Matters

—

There is no doubt that the scale of the artworks produced by Rubens and Velázquez in terms of their physical size and number augmented their effectiveness as indicators of power. But, perhaps unsurprisingly, bigger and bolder examples of art as propaganda feature in art from across a broad spectrum of time. Giant or colossal statues can be found, for instance, in ancient Egypt, especially those that celebrate the reign of Pharaoh Ramesses II (1303–1213 BCF).

My focus here is the *Colossus of Constantine* 312–15 CE (FIG.45), which was a huge statue of the late Roman emperor Constantine the Great (c.280–337 CE). It originally stood in the west apse of the Basilica of Maxentius, which is near the Forum Romanum in Rome. The enormous statue, which was probably around 12 metres high, now exists in fragments, and different parts of the Colossus can be found across Rome. These fragments are powerful images in their own right – the head is 2.5 metres in height and each foot is over 2 metres in length – and were important sources for later artists. It is often argued that Michelangelo's over life-size David 1502, especially the naturalistic treatment of the head and arms, draws inspiration from the *Colossus of Constantine*, which had recently been discovered in Rome. The colossal image represents the emperor while seated, or rather enthroned. Technically it was quite a complex work to execute, comprising a torso made of brick core with a wooden frame, and the head, arms and legs carved in white marble. The use of different materials was not unusual and the torso may have been gilded to add to the overall impression of grandeur. The head is carved in the typical hieratic emperor style of late Roman portrait statues and was perhaps meant to convey the power of the emperor over his subjects. We can imagine

[45] **COLOSSUS OF CONSTANTINE** C.312–15 CE

how this work must have appeared once completed. Its gigantic size would have underscored the grandeur of the image of the powerful Constantine, who was enthroned like the effigy of a god.

Once again we find that there is a connection here between devotional art and art that expresses authority. The *Colossus of Constantine* has an iconic quality that communicates the right to rule. As we have seen earlier in this chapter, this is a characteristic of state portraiture; indeed it is one if its principal functions. We worry less about the likeness of the image than its power as an artwork to confirm such authority. In this way the state portrait has a kind of iconic status not dissimilar to the icons discussed in the chapter on devotion (PP.102–31). Such images or icons may become more powerful through the act of their destruction and this has occurred for religious and/or political reasons across time. Iconoclasm literally means 'image breaking' and refers to this process. We can see this, for instance, in ancient Egypt, where the faces of sculptures of recently deceased pharaohs were obliterated by their successors. In a kind of denial or negation of the power of monarchy, portraits of kings were defaced during the French Revolution. These acts of iconoclasm are not confined to history. In recent times we have witnessed the destruction of statues that once affirmed the cult of an individual ruler, for example in the many sculptures of Vladimir Lenin (1870–1924) that were on prominent display across the former Soviet Union. True to the law of unintended consequences, the images of these oversized works being dismantled and removed from their plinths are in some ways more potent than the originals (FIG.46). Indeed, at the time, the use of high art for the representation of new political ideals did not always sit well with contemporaries. As the Russian artist Alexander Rodchenko (1891–1956) commented:

[46] **STATUE OF LENIN**, BUCHAREST, PHOTOGRAPH 1991

Tell me, frankly, what ought to remain of Lenin: an art bronze, oil portraits, etchings, watercolours, his secretary's diary, his friends' memoirs or a file of photographs taken of him at work and rest, archives of his books, writing pads, notebooks, shorthand reports, films, phonograph records? I don't think there's any choice. Art has no place in modern life. Every cultured modern man must wage war against art, as against opium. Photograph and be photographed!

Since ancient times, monumental sculpture and architecture, perhaps most notably Roman triumphal arches, have expressed power across distance and empires. But Rodchenko's remarks point us towards the ways in which modern techniques of art making have expanded both the formal and the geographical possibilities for the dialogue between art and power. Not only can images be mass-produced for widespread consumption but also electronic media, such as television and more recently the internet, have ensured their ubiquity.

We normally associate art objects with being the original – that is, the only example. There are exceptions, such as *The Virgin of the Rocks* (SEE FIG.08), or where an artist has produced a number of casts of a sculpture, as we saw in Barbara Hepworth's *Figure for Landscape* (SEE FIG.17). Yet we do not see these multiple versions as detracting from the value of the work. By this I mean the cult value rather than the monetary worth, which is also referred to as the aura of an artwork achieved partly through its status as an original. There is another argument that the mass reproduction of works may well actually enhance their aura. We can certainly see this as being the case, for instance, with the use of posters and other visual imagery in the service of political ends. In this way art becomes an element of popular culture and images of power join this omnipresent visual lexicon.

There is No Harm in Repetition
—

The pervasive presence of a commercial culture, which included celebrities and politicians, caught the attention of pop artist Andy Warhol (1928–87). He explored this in his artistic practice by portraying everyday objects, such as *Campbell's Soup Cans* 1962 or his plywood sculptures *Brillo Boxes* 1964. He challenged this kind of production through the use of irony, as here commercially mass-produced consumables became high art. Warhol also used images of famous figures, just like identical consumer goods. When combined with new technologies such as print and television the slippage between fame and obscurity is perhaps best summed up in his remark, 'In the future, everybody will be world-famous for fifteen minutes.'

Warhol included celebrities, especially Hollywood film stars, in his work, as their omnipresence assured their fame in a kind of self-fulfilling prophecy. He discussed his views about this and their visual and cultural potency:

> What's great about this country is America started the tradition where the richest consumers buy essentially the same things as the poorest. You can be watching TV and see Coca-Cola, and you can know that the President drinks Coke, Liz Taylor drinks Coke, and just think, you can drink Coke, too. A Coke is a Coke and no amount of money can get you a better Coke than the one the bum on the corner is drinking. All the Cokes are the same and all the Cokes are good.

In a departure from more traditional techniques of painting, Warhol explored the possibilities of silkscreen printing whereby photographs could be transferred onto canvas. In this way, mass-produced consumer products and people appeared in a different medium from

those in which they were usually encountered. They moved from being ephemeral images to lasting works of art, partly though the added gravitas of the medium. In a double twist of irony, the screen prints also became highly valued artworks that continue to sell for very high prices. In the example I have chosen, Warhol mixes his approach to mass production and the power of the celebrity with the expression of political authority. He combined his screen-printing technique with totalitarian propaganda to critique the cult of personality surrounding Chinese ruler Mao Tse-tung (1893–1976).

There are a number of prints of Mao, some of which are extremely large, so mimicking the very realistic, photographic representations of the political figure that were ubiquitous throughout China. The visual consistency of these images worked to deny the individualism that Mao despised. In contrast to these giant portrayals, Warhol chose to daub Mao's face with garish colours to make personal, rather painterly, works (FIG.47). Through irony and the exploitation of media and technique, Warhol questions and subverts the way power is communicated through popular culture and mass media.

I would like to explore further the strategies used by artists to question or destabilise both our perception of power relationships and the power of the artist in being able to do this. The fusion of innovative media and techniques of art making with critiques of popular culture, perceptions and power politics are all at play in Sonia Boyce's (b.1962) *From Tarzan to Rambo: English Born 'Native' Considers her Relationship to the Constructed/Self Image and her Roots in Reconstruction* 1987 (FIG.48).

The complex title that evolved as the work was being made requires some unpicking, so helping us to understand how Boyce challenges populist expressions of power and identity. There is an autobiographical

[47] ANDY WARHOL, **MAO TSE-TUNG** 1972

trace in this work, as she is referring to herself in the phrase *English Born 'Native'* and the ways in which as a black woman artist she questions the stereotypes and prejudices implicit within it. Boyce appears in the photo booth images that feature in the photomontage, which was partly influenced by a photographic montage in the French surrealist magazine, *La Révolution surréaliste* (Paris, no.12, 15 December 1929). Boyce also refers to the Mexican surrealist artist Frida Kahlo (1907–54) through the idea that the unconscious plays an important role in 'the perpetuation of mythic stereotypes'.

The picture developed from Boyce's desire to consider the relationship between her own 'self-image' and the one offered by a predominantly white society through the mass media. It is here that mass-produced images and popular culture come into play along with the influence of Hollywood on our perceptions of power as manifest in the Tarzan and Rambo films. The Tarzan films present black and white audiences with an exotic and exciting view of Africa, over which the white man (Tarzan, the son of white parents) is master. Boyce feels that the new white warrior hero, epitomised by the mixed race Rambo, represents, like Tarzan, a crisis of white identity. In both cases the black person appears 'other' against which a positive image of white identity (and power) can be constructed. In this way Boyce draws attention to a white-dominated mass media in which black role models have been scarce and often negative.

The artwork uses a range of media, predominantly photography, to question the effect of white power on the African diaspora. In the first place this resulted from the dispersion of African peoples across the world as a consequence of slavery and colonisation. Following on from this Boyce examines the manner in which identities and stereotypes of black people are constructed visually and the ways these images are consumed by the viewer. These social and cultural forces behind

[48] SONIA BOYCE, **FROM TARZAN TO RAMBO: ENGLISH BORN 'NATIVE'
CONSIDERS HER RELATIONSHIP TO THE CONSTRUCTED/SELF
IMAGE AND HER ROOTS IN RECONSTRUCTION** 1987

the construction of black identities are complex and intertwined. We know that Boyce wanted black people in particular to recognise and confront them:

> I was actually thinking about audience, and thinking about ways in which different people will come to this piece. I've not heard any black person talk about it, mainly because the piece hasn't ... really been seen very much ... I don't know how other black people respond to seeing these connections put together ... I'm sure it will be quite painful.

Boyce is keen for the audience/viewer to participate in the work in order to understand what she is trying to say:

> When I was trying to explain it, I had to draw a diagram for myself. It was almost like a map of all the various connections that I was trying to make. In a way it's difficult to know how much of that comes through in a piece.

By using comic books as a source, Boyce hoped to illuminate how popular culture across a broad sweep of time contributes to the process of self-identification for black people, despite the fact that it is often produced for a white audience. The white viewer is offered a white male hero as a role model. In contrast, the black viewer is presented with an anonymous group of 'natives', who are shown to be living in the jungle and adhering to sinister and barbaric pagan practices, possibly including human sacrifice. Both the artist and the work challenge theconstruction of myths from reality and in so doing question power relationships that might otherwise be considered normative.

Moved by Art/Art that Moves
—

The work of the Chinese artist Ai Weiwei (b.1957) draws together some of the threads that have run through our discussion of art and power. I would like to return to the questions raised at the beginning of this chapter about cultural appropriation and the expression of authority. From 1981 to 1993 Ai Weiwei lived in the United States where he was influenced by the conceptual art of Marcel Duchamp (1887–1968), Andy Warhol and Jasper Johns (b.1930). He is also a keen photographer and produced a collection of images now known as the New York Photographs. My interest here is in his reinterpretation of the twelve bronze animal heads that represent the traditional Chinese zodiac, *Circle of Animals/Zodiac Heads* 2010 (FIG.49), which was his first major public sculpture project. Ai Weiwei's models for these heads are the sculptures that once formed the fountain clock of the Yuanming Yuan, at the imperial retreat in Beijing. This had been designed in the eighteenth century by two European Jesuit missionaries at the court of the Emperor Qianlong of the Qing dynasty. The twelve heads were originally part of the fountain clock situated in the splendid European-style gardens of the Yuanming Yuan. In 1860, French and British troops plundered the Yuanming Yuan and the heads were taken. In this way they represent the imperial power of the Chinese emperors and of empire-building Europeans.

The work focuses our attention on questions of cultural appropriation and re-appropriation and explores the status of the original in relation to a duplicate or copy. Moreover, Ai Weiwei reinterprets these objects and reproduces them in an oversized scale, which again picks up on a key theme in this chapter.

Circle of Animals/Zodiac Heads is the centrepiece of a touring exhibition that was launched in New York in May 2011. The exhibition

[49] AI WEIWEI, **CIRCLE OF ANIMALS/ZODIAC HEADS** 2010

will travel for several years ensuring global reach and reminding us of the peripatetic qualities of art. Ai Weiwei remains a stern critic of his native China as he sees the powerful communist regime, despite the recent embracing of global capitalism, as stifling creativity. To conclude, I would like to refer to a comment made by Ai Weiwei that resonates with Tinguely's words at the beginning of this chapter and relates to the general theme of this chapter:

> In a society that restricts individual freedoms and violates human rights, anything that calls itself creative or independent is a pretence. It is impossible for a totalitarian society to create anything with passion and imagination.

This woman's work is exceptional. Too bad she's not a man

EDOUARD MANET (1832–83) ABOUT BERTHE MORISOT

Sex

This woman's work [Berthe Morisot] is exceptional. Too bad
she's not a man.

Edouard Manet (1832–83)

In this chapter I would like to think about the two main ways in which
sex and art intersect. If we take sex to mean gender, we can explore
this through the representation of gender and the gender of the
artist, and how it affects the perception of them and their practice. In
addition, I shall consider the depiction of the sex act itself and art as
pornography. My starting point is how the two sexes are represented
in art. In Western art the tradition of studying from life has been a
dominant force in the depiction of the human body. We see evidence
of this in the art of Greco-Roman antiquity and from the Renaissance
onwards. There are examples throughout this book – look, for
instance, at the Christ Child in Leonardo's *The Virgin of the Rocks*
(SEE FIG.08), or Caravaggio's portrayal of St Matthew (SEE FIG.39). Life
drawing became one of the mainstays of artistic training alongside a
good knowledge of materials and techniques. The study of the human
body and the accurate rendering of anatomy became benchmarks of
artistic prowess. As Vasari remarked:

> The best thing is to draw men and women from the nude and
> thus fix in the memory by constant exercise the muscles of the
> torso, back, legs, arms and knees, with bones underneath.

Despite Vasari's apparently egalitarian comment, I would argue that
the sexes have been represented differently in art. We can begin
to explore this through the visual concepts of naked and nude. It is

[50] TITIAN (TIZIANO VECELLIO), **DANAË RECEIVING THE SHOWER OF GOLD** 1553–4

helpful to think about how we differentiate between naked and the nude, and the effect these concepts have on the way in which we view and understand art.

Any mention of 'the nude' tends to bring to mind images of the female body, which since the Renaissance has been presented in art as the object of male desire. We see this, for instance, in the work of the sixteenth-century Venetian artist Titian (1485–1576). He produced many pictures, which can be described as sensual, erotic or simply 'soft' porn. In these images the women are nude, rather than naked, as they are other-worldly, mythical figures that are distanced from everyday life. Some of Titian's representations have become standard points of reference for subsequent artists when depicting the female nude. My example here is *Danaë*, sometimes known as *Danaë Receiving the Shower of Gold* (FIG.50). There are at least five versions of this picture series, all painted between 1553 and 1556. Once again, we see how the classical world, and indeed the stories from Ovid, influences the art of the West. Taking heed of a prophecy that her firstborn would kill him, King Acrisios incarcerated his daughter Danaë to ensure her chastity. Nevertheless, the god Zeus fell in love with her and descended from Mount Olympus in one of his many guises. He appeared as a shower of gold and succeeded in seducing Danaë. What a story! Chastity, lust, seduction and, of course, a prophecy fulfilled, as Danaë's son by Zeus, Perseus, did kill his grandfather.

Titian painted several versions of this picture, some of which were for Philip II (1527–98) of Spain. Each one differs in detail and the quality of execution depending on the contribution of members of Titian's workshop. However, in all of the versions Danaë is depicted as a voluptuous recumbent figure with her legs open and her left leg arched. Titian's choices of how to represent the female nude became the norm in Western art for centuries. The reclining female nude, whether an

image of Danaë, or any other mythological nymph or goddess or indeed a courtesan as we see in the *Venus of Urbino* 1538, became the standard pose for this kind of erotic art.

The many versions of the *Danaë* picture had a considerable impact on Titian's contemporaries. We know, for instance, Michelangelo's opinion of it as it is reported by Vasari:

> For I am conscious that if this man was as much assisted by art, as he is by nature, no mortal could go further. He has a noble spirit; but as of present having no knowledge of design, he in his imitations of the life corrects nothing nor attempts to make it better, though possessed of a manner so easy and beautiful, so full of truth and animation. But certain it is, that not having studied the best work of the ancients, the Venetians know not how to mend or how to give a grace and perfection to their works beyond their model, which is never perfect in all parts. The moderns in general cannot, from their own resources, be correct, but are obliged to make a literal copy of the object before their eyes, not knowing what it ought to be.

Michelangelo's comment certainly tells us how Titian was admired by his contemporaries, but it also points to two other important themes. Firstly, the differentiation in the Renaissance between drawings and colour, which is known as the *disegno* versus *colore* debate. Venetian painters were better known for their modelling in colour than for their draftsmanship and this is at the heart of Michelangelo's thoughts about Titian. This leads on to the second point that is important for this chapter, as the privileging of drawing underpinned the academic tradition in art where studies from life and the study of classical art were essential aspects of artistic training and practice. These cohere

around the representation of the nude and here we find a discrepancy between the male and female body.

Certainly in ancient Greek and Roman times the male nude was considered the pinnacle of perfection. We have seen this in the *Apollo Belvedere* where the face and proportions of the figure present us with the idealised human form, which is based on that of the gods (SEE FIG.02). This tradition continued into the Renaissance where we find Cennino Cennini giving advice to artists in his *The Craftsman's Handbook*:

> Take note that, before going any farther, I will give you the exact proportion of a man. Those of a woman I will disregard, for she does not have any set proportion.

The female body was regarded less favourably than its more structured muscular male counterpart. That said, classical sculptures of female goddesses were also influential from the Renaissance onwards. The figure type known as the Venus *pudica*, where the goddess's hand covered her modesty, became a conventional pose for the standing or reclining female nude. The way nature and antiquity were combined was ingrained into artistic theory and practice, and the artists of Antiquity and of the Renaissance were considered to have established an ideal synthesis of the human body without being distracted by individual characteristics.

Virtue and Vice
—

For the eighteenth-century German antiquarian Johann Winckelmann (1717–68), the ideal beauty found in Greek statues could be embodied only by the male nude. Winckelmann's detailed study of Roman antiquities enabled him to identify that Roman sculptures were in

fact copies of Greek art. We can see this in the use of materials, as the Greeks usually worked in bronze while the Romans copied these works in marble. As we discovered in the chapter on materials, the different qualities of these two media impact on the artwork. In the *Apollo Belvedere* the tree trunk needed to be part of the composition to support the weight of the marble. For a work in bronze this would not be necessary due to the tensile strength of the material. In his treatise *Gedanken über die Nachahmung der griechischen Werke in der Malerei und Bildhauerkunst* (1755) (*Thoughts on the Imitation of Greek Works in Painting and Sculpture*), Winckelmann asserted that 'The only way for us to become great, yes, inimitable, if it is possible, is the imitation of the Greeks'. But he was not advocating slavish copying: 'what is imitated, if handled with reason, may assume another nature, as it were, and become one's own.' Neoclassical artists attempted to revive the spirit as well as the forms of ancient Greece and Rome, and many of these were expressed through the male body. Indeed, the concept and the word 'hero' stems from ancient Greece. The visual representation of a mythological god or a mortal transcending his human condition can both become an *exemplum virtutis* (a moral allegory, or example of virtue) and embody an ideal. The admiration for classical art and culture is fundamental to academic painting where students were trained in formal schools or academies that became prevalent in Europe in the eighteenth century. In France, for instance, students studied at the Académie Royale then at the Académie des Beaux-Arts, where they worked from drawings, engravings, sculptures and (male) life models.

We have seen the results of this kind of training and approach in the work of the eighteenth-century French painter Jacques-Louis David and his *The Oath of the Horatii* (SEE FIG.35). Here, the heroic ideal (as it may have appeared to some viewers at least) of the Horatii brothers is expressed through their physical perfection. Although the figures

[51] POLLAIUOLO, **THE MARTYRDOM OF ST SEBASTIAN** 1475

are not nude, it is clear that David's understanding of anatomy is gleaned as much from the ancient Greeks as it is from life. The study of the ancients was indeed a mainstay of academic art. Sir Joshua Reynolds (1723–92), first president of the Royal Academy of Arts in London, confirmed the combined influence of nature and the art of the past:

> A painter must not only be of necessity an imitator of the works of nature ... but he must be as necessarily an imitator of the works of other painters. This appears more humiliating, but is equally true; and no man can be an artist, whatever he may suppose, upon any other terms.

This view is not confined to the eighteenth century. Although with slightly different emphasis, Cézanne, one of the leading post-impressionist painters, remarked that

> The Louvre is a good book to consult, but it must only be an intermediary. The real and immense study that must be taken up is the manifold picture of nature.

Heavenly Bodies
—

The male nude has also had an important role to play in Christian art. From the fifteenth century onwards, nudity gradually became accepted for the depiction of figures such as the martyred Christ or St Sebastian. Antonio and Piero del Pollaiuolo's *The Martyrdom of St Sebastian* 1475 (FIG.51) shows how an interest in anatomical accuracy was combined with a religious image. St Sebastian is all but nude as he is bound to a stake whilst being shot with arrows. The Pollaivolo brothers' interest in the male nude is also evident in

the figures of the archers. There are three poses used for the six figures, each of them orientated slightly differently. We know that all the figures were studied from life, as drawings still exist. This mode of representation, where the modesty of the subject was retained through some strategically placed drapery, had been encouraged by Catholic theologians who advocated the union of the sensory and the spiritual, which was emphasised by the nudity of the subject.

The complex relationship between the representation of the male and female body also exists outside the frame of Christian art. We saw in the chapter on devotion (PP.102–31) that there are variations between religious beliefs about the portrayal of a divine being in his or her corporeal state. Hinduism teaches that the Absolute has no form and it exists beyond time; as such, it cannot be represented visually. However, as an aid for the faithful, the Absolute can be alluded to by way of the masculine trinity, or *trimurti*, composed of Brahma, Vishnu and Shiva, and its complement, the Great Goddess Devi, who personifies the female aspects of spirituality. There are strict conventions, laid out in religious texts, for the depictions of these deities. For example, a male god should have hair only on his head, eyelashes and eyebrows. Moreover, he should have an imposing appearance and wear impressive jewellery.

There are also rules that govern the depiction of women, whether deities or mortals. These concentrate on her physical form, which is always measured against that of her male counterpart. We see this, for example, in the stipulation that the height of a woman should be no more than her (male) partner's shoulder. Equally, attention is drawn to the reproductive aspects of her body: her waist should be smaller than the man's and her hips should be emphasised. Once again, the female figure remains secondary and is defined by that of the masculine body.

Naked or Nude

—

Edgar Degas touches on a fundamental question about our role as a viewer of representations of the unclothed male or female body:

> Hitherto the nude has always been represented in poses, which presuppose an audience. But my women are simple, honest creatures who are concerned with nothing beyond their physical occupations ... it is as if you were looking through a keyhole.

If we are the intended, or indeed the unintended, audience should we feel embarrassed? And, if not, what devices has the artist used to legitimise his (usually) subject and make us feel less like a voyeur peeping through a keyhole?

I would like to discuss this further in my next example of a reclining female figure, which prompts the question: at what point does a nude become naked? Edouard Manet was one of the first painters to reject the academic classical tradition of art and address himself to painting the world around him as he saw it. His subjects and his techniques of representing them have led Manet to be described as a pioneering painter of modern life.

Manet's *Olympia* 1863 (FIG.52) caused a stir when it was exhibited at the Paris Salon in 1865. The shock value of the work is not the depiction of a reclining female nude – we have already seen that this subject had a long lineage – rather audiences were astonished that the purpose of the artwork was so blatantly expressed. It was as if the genre had been unclothed and its real purpose exposed. The subject was both physically and metaphorically naked. We see Olympia lying on her bed very much in the tradition established by Titian but, unlike Danaë, she stares out at us and meets our gaze in

[52] EDOUARD MANET, **OLYMPIA** 1863

an almost confrontational way. Furthermore, the contrast between the two female subjects is heightened as it is clear Olympia is a prostitute rather than a mythical princess who is seduced while incarcerated by her father to protect her chastity. The visual clues for Olympia's profession include the orchid in her hair, her jewellery and her name, which was often associated with prostitutes. *Olympia* sheds the cloak of respectability provided by the allusion to the classical world and defies the academic canon of painting by her nakedness. Manet's technique of painting also challenges the established tradition as he employs quick broad brushstrokes to give large areas of solid colour. In this way the picture recalls the preparatory stages for oil painting that we discussed on p.51, where colour is blocked out before being modelled. The 'realness' is emphasised by the harsh lighting that accentuates the 'rawness' of the image of Olympia, especially her yellowish flesh; she is not an idealised alabaster-skinned nude.

There is an ironic twist to this picture. We know the model was Victorine Meurent (1844–1927). She was Manet's favourite model and also worked for other artists including Thomas Couture (1815–79), Edgar Degas and Alfred Stevens (1823–1906). Meurent was an artist in her own right and exhibited six times at the Paris Salon. Indeed, in 1876 her paintings were selected by the jury for inclusion at the Salon, when Manet's work was not. In contrast to Manet, Meurent embraced the academic tradition in art and her entry for the Académie des Beaux-Arts in 1879 was hung in the same room as that submitted by Manet.

The instance of Meurent – model, muse and artist – prompts me to think about the sex of the artist and the influence this has had on our perception of art. My purpose here is not to inscribe women artists into the canon of art, but I will focus on women artists. Indeed I am prompted if not provoked by Degas's comment,

'I don't admit that a woman [Mary Cassat] draws that well.'

An appropriate response to this comes from Artemisia Gentileschi (1593–1656). She was a prominent female artist working in Italy in the seventeenth century, who wrote to her patron, Don Antonio Ruffo, on 13 November 1649:

> My illustrious lordship, I'll show you what a woman can do. They [clients] come to a woman with this kind of talent, that is, to vary the subjects in my painting; never has anyone found in my pictures any repetition of invention, not even of one hand.

Gentileschi was in fact one of a number of women artists in Italy at this time. Her practice seems bound by the problems that would not befall a man. She remarked:

> I have made a solemn vow never to send my drawings because people have cheated me. In particular, just today I found ... that, having done a drawing of souls in Purgatory for the Bishop of St Gata, he, in order to spend less, commissioned another painter to do the painting using my work. If I were a man, I can't imagine it would have turned out this way.

My example of Gentileschi's work is *Judith Slaying Holofernes* (FIG.53), of which two versions exist. The first was completed between 1611–12; the second c.1620. The painting depicts an apocryphal scene from the Old Testament that tells of the delivery of Israel from the Assyrian general Holofernes. Gentileschi chooses to portray the moment when Judith and her maidservant behead the general after he has fallen into a drunken sleep. This work runs parallel with that of her contemporary Caravaggio in terms of its realistic representation, which can be shocking, and the use of light and shade to heighten

[53] ARTEMISIA GENTILESCHI, **JUDITH SLAYING HOLOFERNES** C.1620

dramatic effect. In the context of this chapter I am reluctant to say it was influenced by Caravaggio, but rather that the picture belongs to the body of seventeenth-century work that shared his preoccupations. The painting shows a level of realism in the physical act of violence that the two women are in the middle of performing. Their struggle to wield the knife and to wrestle with Holofernes as he reaches out in a struggle for survival is shown in gory detail. Gentileschi also inscribed herself in the artwork, as Judith is a self-portrait. The biographical trace becomes stronger as her mentor, Agostino Tassi (1578–1644), is portrayed as Holofernes. Tassi was tried and convicted of the rape of Gentileschi, and the trial was by some accounts more traumatic for the victim than for the perpetrator. Perhaps Gentileschi was working out some of her anger against Tassi and the trial in this picture. The intertwining of her artistic practice and personal history finds an echo in Georgia O'Keeffe's remark:

> I have had to go to men as sources in my painting because the past has left us so small an inheritance of woman's painting that had widened life ... Before I put a brush to canvas I question, 'Is this mine? Is it all intrinsically of myself? Is it influenced by some idea or some photograph of an idea which I have acquired from some man?'

Judith (Gentileschi) is not a passive object like Danaë, nor is she a working woman like Olympia. Gentileschi's practice points to the complex ways in which sex and art interact and the wide range of media used by artists to explore this.

The biographical trace and a commentary on sexual politics find a reprise in the work of Sarah Lucas. *Pauline Bunny* (FIG.54) was originally part of an installation and exhibition entitled *Bunny Gets Snookered* 1997. The artwork was one of eight similar figures arranged on and

around a snooker table at the London gallery Sadie Coles HQ. In the work Lucas makes reference to the bunny girl as an object of male pleasure and the male-dominated, predominantly working-class game of snooker. Through the reference to snooker, Lucas also alludes to her own background and upbringing.

Each figure in the artwork is made of a pair of different coloured tights that corresponds to the colours of the snooker balls. The tights are stuffed with padding to make the 'bunny girl' forms that give an image of acquiescent womanhood. Pauline is made of black tights – black being the highest value ball on the table – and she is the only 'bunny' with a name. The black tights or stockings also present Pauline in the guise of seductress, but any suggestion of power that Pauline might have is subverted by the passivity of the floppy, stuffed body with dangling limbs. Moreover, the figure is attached to an office chair to emphasise the submissiveness of the subject.

Lucas challenges gender stereotypes in this work both in the way she depicts her subject and in her choice of title, which is a play on words and on our preconceived ideas. We might expect a lewd sexual image of a 'bunny girl' but the sagging body and literal empty head present a droll riposte to the viewer's expectations. *Pauline Bunny* is not the mythical Danaë turning her head away from the viewer, nor is she the immodest Olympia staring out towards us; she denotes a different kind of femininity. Certainly she is a sexual object but the process of objectification is in itself comic and slightly absurd – *Pauline Bunny* is not desirable nor is she a seductress. Her artistic lineage perhaps lies more in the tradition of using dolls to represent women and/or femininity. This came to the fore in the work of the surrealist artist Hans Bellmer (1902–75), who made dolls and photographs of dolls that emphasise the sexuality of young girls. Understandably, this work is not without its controversies.

[54] SARAH LUCAS, **PAULINE BUNNY** 1997

The use of dolls or dummies takes on a new significance in the work of Cindy Sherman (b.1954). In her series of photographs called *Sex 1989* she staged medical dummies as if *in flagrante delicto*. Sherman's inclusion of prosthetic body parts had begun with her 1981 *Centerfold* series, which make reference to the stereotyping of women in visual media. Sherman said of this series:

> I wanted a man opening up the magazine to suddenly look at it with an expectation of something lascivious and then feel like the violator that they would be. Looking at this woman who is perhaps a victim. I didn't think of them as victims at the time ... But I suppose ... Obviously I'm trying to make someone feel bad for having a certain expectation.

In the work of Gentileschi, Lucas and Sherman, we see how women artists have addressed issues of the objectification of women for a male audience and how they have inscribed themselves in their artworks in a number of ways. If we think back to the work of Carolee Schneeman, we see how one of the photographic stills from *Eye Body* makes a direct repost to the reclining female nude (SEE FIG.21). Here the object is the artist herself, and Schneemann said of this work:

> I wanted my actual body to be combined with the work as an integral material – a further dimension of the construction ... I am both image-maker and image. The body may remain erotic, sexual, desired, desiring, but it is as well votive: marked, written over in a text of stroke and gesture discovered by my creative female will.

And So to Bed

—

Tracey Emin's work *My Bed* 1998 certainly caused a stir and attracted much media attention when it was exhibited as part of the Turner Prize exhibition at Tate Britain in 1999. The artwork comprises the artist's bed together with bedroom objects. Emin chose to present her bed as it had been when she had remained in it for several days suffering from depression. It tells the story of this point in the artist's life, using real objects as part of the narrative. The bed sheets were stained with bodily secretions and the floor had items from the artist's room including articles such as slippers but also those that speak of sexual encounters and bodily functions, for instance used condoms and a pair of knickers with menstrual period stains. The representation of these bodily functions and references to sexual intercourse caused outrage. The viewing public would seem to prefer that copulation is referenced by a shower of gold falling on Danaë and that Olympia's bed (her workplace in fact) appears to be freshly laundered.

Emin sees *My Bed* as a pendant piece to *Everyone I Have Ever Slept With 1963–1995* 1995, which is also known as 'my tent' or 'the tent' (SEE FIG.26). The artwork was a tent appliquéd with 102 names of the people she had slept with up until the time of its creation. Unsurprisingly, the title of the work is often misinterpreted as a euphemism indicating the artist's sexual partners. In fact, it is more subtle than that for Emin. The list of names is far more domestic in character, providing glimpses of scenes from the artist's life. The names include family, friends, drinking partners, lovers and even two numbered foetuses. She simply shared a bed with many of those listed, such as her grandmother. Perhaps this tells us something more about our perceptions of the relationship between sex and art.

There is, of course, nothing new in history. The representation of sexual acts is found in a range of media across a broad spectrum of time and geographies, from the sculptural decoration of Hindu temples and illustrations of the *Kama Sutra* (400 BCE–200 CE) to the homoerotic photographs of Robert Mapplethorpe (1946–89). Indeed, Mapplethorpe leads me back to where I began this chapter. If we return to the notion of the male nude as celebrated by Mapplethorpe we uncover a very different kind of world from the idealised beauty so admired by Winckelmann.

The men from the upper echelons of Greek society participated in banquets called symposia, which took place in the men's quarters of private houses with the participants reclining on couches or day beds called *klinai*. As well as being the subject of ancient texts by authors such as Plato (c.427–347 BCE) and Xenophon (c.430–354 BCE), symposia are illustrated on various types of Greek vase. The emphasis at these events was on cerebral and sybaritic pleasures and alongside intellectual exchange there was much heavy drinking.

Like their neoclassical followers, the ancient Greeks admired male beauty and it was not uncommon for unmarried men to engage in both homosexual and heterosexual acts. The only women permitted to attend symposia were prostitutes (*hetaira*), who are frequently shown nude in scenes depicting the symposia. The various kinds of sexual activity practised at symposia formed the basis of many of the images on Greek vases, together with those portraying the results of excessive drinking, such as vomiting. The bodily functions of ancient Greek men, sexual or otherwise, seem to wear the cloak of classical respectability.

The work of the Euaion painter dating from the mid-fifth century BCE is typical of the vases that were decorated with images of symposia. The style of painting is known as Attic red-figure, as the reddish

[55] EUAION PAINTER, **KYLIX** C.460–50 BCE

Athenian clay was used as a base colour over which black lines could emphasise anatomical detail. The kylix, or shallow cup, (FIG.55) shows a boy serving wine at a symposium. We see men reclining on klinai and the boy holding a kylix to offer wine in his left hand whilst carrying a wine jug, or oenochoe, in his left. The red-figure style enables the painter to delineate the anatomy of the three male figures that are either part-clothed or naked, and to represent the engaging gaze between the boy servant and the man to whom he serving the wine.

The Final Word

—

In many ways the representation of the symposia goes to the heart of one of the main themes of this book: the ways in which our view of art is culturally determined. My focus has been the Western viewpoint and Western artworks from a broad spectrum of time. Greek vases depicting the symposia are at once venerated art forms from the classical Western past as well as being representations of explicit sexual acts and sybaritic excess. This is not unique to depictions of sex. In David's *The Oath of the Horatii* (SEE FIG.35) we saw how killing members of one's own family could be conceived of as both an *exemplum virtutis* and as an act of devotion to the state above all else. Similarly, classical portrait types were used as expressions of power. This is seen, for instance, in Velázquez's equestrian portrait of Philip IV of Spain (SEE FIG.44).

I have looked mostly at Western art while exploring points of reference and contrast with art objects from across the globe. That said, we began this journey through art in a cave, thinking about what the pigments and incisions on the walls might tell us about artworks and how we look at them. Lascaux (SEE FIG.05) not only allowed us to discuss materials but also to consider how the images operated as expressions of devotion, mind and power. Sex, of course, came into it, with our imagined notion of the gender roles of Mr and Mrs Caveman and which of them might have produced the images. My aim in starting with this example was to set up a series of questions that challenge our assumptions about art and lead us to new ways of looking. I have peppered the text with artists' voices as their comments add a layer of richness and offer a discourse with my own point of view. To whom, then, do I leave the final word in this book? I think it must be you, dear reader.

Sources, Index and Credits

Acknowledgements
—

This book is the result of many years of thinking and writing about art. Conversations with many colleagues have been stimulating and provocative in the formulation of my thinking. Mindful of the risk of accidental exclusion, I wish to say a general thank you to you all. I am also grateful to Roger Thorp, Nicola Bion, Juliette Dupire and Miriam Perez at Tate Publishing, and Robert Boon and James Ward at Inventory Studio, for their work on this book. I would like to thank my 'focus group': Charlie, Georgie, Jessica, and Maxwell, as well as Hilary and Signe for giving me candid opinions on images, designs and the general tone of the text. And not least my thanks go to Nigel for his support – this book is for him.

A Note on Sources
—

The bibliography of the stories or histories of art is extensive and this is complemented by a growing number of studies that introduce the reader to art, rather than its history, and contemporary trends to make connections between the art of different cultures and time periods. Although this book benefits from this rich tradition of writing about art and aims to add to this body of work, any list of sources will doubtless be incomplete. Below is a brief bibliography that is indicative of the many texts that are available. Reference is also made to written sources that are contemporary to the artworks being discussed, and many of these are still available in reprinted/translated versions. Throughout the text I included quotations from artists as I wanted to

add their voices to the discussion. Many of these were sourced via a number of websites dedicated to artists' quotations and verified by searching again for these. Museum and gallery websites were also a helpful resource in this regard: http://umich.edu/~motherha/ is an excellent portal through which to access web-based resources. Some suggestions for further reading:

Dana Arnold, *Art History: A Very Short Introduction* (Oxford University Press, 2004)
John Berger, *Ways of Seeing* (Penguin, 1972 reprint 2008)
Jacob Burckhardt, *The Civilisation of Renaissance Italy* (1860); modern ed. Trans S G Middlemore (Phaidon, 1961)
Cennino Cennini, *The Craftsman's Handbook*, trans Christiana J Herringham (Allen and Unwin, 1899)
Jacques Derrida, *The Truth in Painting* (1978)
Ernst Gombrich, *The Story of Art* (1950); 16th revised ed. (Phaidon, 1995)
Immanuel Kant, *Critique of Judgement* (1790)
Norbert Lynton, *The Story of Modern Art* (Phaidon, 1994)
Alexander Nagel, *Medieval Modern: Art out of Time* (Thames & Hudson 2012)
Linda Nochlin, *Women, Art and Power,* (Harper and Row 1988)
Griselda Pollock and Rozsika Parker, *Old Mistresses,* (Routledge and Keegan Paul, 1981)
Giorgio Vasari, *Lives of the Artists* (1550, 1568); modern ed. Trans George Bull (Penguin 1987)
Leonardo da Vinci edited by Irma A Richter (Oxford World's Classics, 1998)
Johann Joachim Winckelmann, *Imitation of the Painting and Sculpture of the Greeks* (1755); modern ed. *Reflections on the Imitation of Greek Works In Painting and Sculpture*, trans Elfriede Heyer and Roger C Norton (Open Court, 1987)

PHOTO CREDITS

Photo: akg-images/MPortfolio/
Electa p.49

Photo: akg-images/Rabatti –
Domingie p.123

Basilica di San Marco, Venice,
Italy/Cameraphoto Arte
Venezia/The Bridgeman Art
Library p.14

Photo by Hubert Becker p.127

The Calouste Gulbenkian
Foundation/Scala, Florence
p.129

Contarelli Chapel, S. Luigi
dei Francesi, Rome, Italy/The
Bridgeman Art Library p.125

Detroit Institute of Arts, USA/
Bridgeman Art Library p.80

Froehlich Collection, Stuttgart
p.152

Galleria dell' Accademia,
Florence, Italy/The Bridgeman
Art Library p.54

Galleria degli Uffizi, Florence,
Italy/The Bridgeman Art Library
p.176

Images courtesy of the artist
and AW Asia. Photo: Ding Musa,
2011 p.157

Image courtesy of the artist and
Gagosian Gallery p.99

Image courtesy of the artist and
P.P.O.W Gallery, New York p.67

Louvre, Paris, France/Giraudon/
The Bridgeman Art Library p.24

Mauritshuis, The Hague, The
Netherlands/The Bridgeman Art
Library p.52

© 2014. Image copyright The
Metropolitan Museum of Art/
Art Resource/Scala, Florence
pp.10, 30, 42, 74, 120

© The National Gallery, London
2014 pp.27, 87, 106, 108, 169

New York Public Library, USA/
The Bridgeman Art Library p.76

© Photononstop/SuperStock
p.20

Prado, Madrid, Spain/The
Bridgeman Art Library pp.138,
164,

Prado, Madrid, Spain/Giraudon/
The Bridgeman Art Library p.142

Photographed by Prudence
Cuming Associates Ltd p.83

Photo: Martin Ries/Gannett Ries
Digital Designs©2014 p.63

REX/Sipa Press p.148

© RMN-Grand Palais (musée du
Louvre)/Gérard Blot/Christian
Jean p.113

© RMN-Grand Palais/Béatrice
Hatala p.21

© RMN-Grand Palais (musée du
Louvre)/Christian Jean/Hervé
Lewandowski p.140

© RMN-Grand Palais (musée
du Louvre)/Hervé Lewandowski
p.181

© RMN-Grand Palais (musée
d'Orsay)/Hervé Lewandowski
p.173

© 2014. Photo Scala, Florence/
Luciano Romano - courtesy
of the Ministero Beni e Att.
Culturali p.56

© 2014. Photo Scala, Florence
– courtesy of Sovraintendenza di
Roma Capitale p.146

© Tate Photography pp.17, 33,
44-5, 58, 61, 64, 90, 93, 97,
111, 154-5, 179

Vatican Museum, Rome/
Universal History Archive/UIG/
The Bridgeman Art Library p.13

© Victoria and Albert Museum,
London p.116

Photo: Stephen White. Courtesy
Jay Jopling/White Cube p.85